IMAGES
of America

SEATTLE'S
RAVENNA
NEIGHBORHOOD

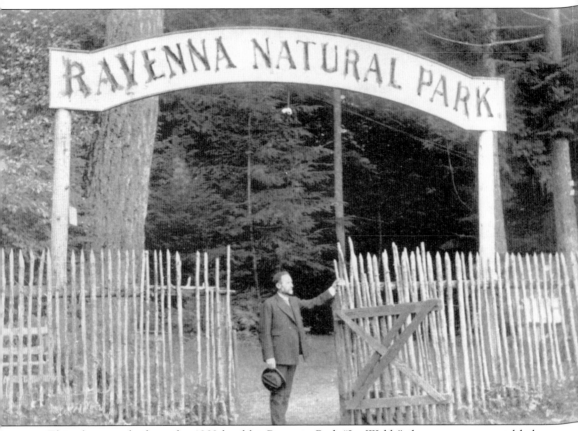

This photograph, from the 1903 booklet *Ravenna Park "Im Walde"* shows a man, most likely owner W. W. Beck, at the entrance to the park. Admission prices were 25¢ for adults and 10¢ for children, with an annual family ticket price of $5. In 1902, more than 10,000 people paid to visit "a safe, clean, and beautiful place for women and children—deputy sheriff in charge," according to the booklet. (Courtesy Peter Blecha.)

ON THE COVER: Two children frolic in Ravenna Park's creek in this *c.* 1891 photograph. They appear to exist isolated from all civilization, frozen in an idyllic time. In 1890, *Seattle Illustrated* wrote: "Nowhere . . . can one find a retreat of this size which so harmoniously combines the rugged and the picturesque with the quiet, peaceful and lovely. The whole effect is startling . . . as if nature had specially exerted itself to make this a park." (Courtesy UW Special Collections.)

IMAGES
of America
SEATTLE'S
RAVENNA
NEIGHBORHOOD

Ann Wendell

ARCADIA
PUBLISHING

Published by Arcadia Publishing
Charleston SC, Chicago IL, Portsmouth NH, San Francisco CA

Printed in the United States of America

Library of Congress Catalog Card Number: 2006933258

For all general information contact Arcadia Publishing at:
Telephone 843-853-2070
Fax 843-853-0044
E-mail sales@arcadiapublishing.com
For customer service and orders:
Toll-Free 1-888-313-2665

Visit us on the Internet at www.arcadiapublishing.com

*To my parents, Ted and Virginia Wendell, for deciding to move to Seattle
and make the beautiful neighborhood of Ravenna their home.*

CONTENTS

ACKNOWLEDGMENTS

Seattle is an area that is blessed with a wealth of excellent libraries, archives, and museums. In particular, I would like to thank the staff at the University of Washington Libraries Special Collections, Seattle Public Library, Seattle Municipal Archives, and Museum of History and Industry. I would also like to acknowledge my reliance on HistoryLink.org, the online encyclopedia of state and local history for Washington; and King County Snapshots, an online catalog of local historical images. NortheastSeattle.com; Ravenna-Bryant Community Organization; and local newspapers the *Seattle Times*, *Seattle Post-Intelligencer*, and *North Seattle Herald-Outlook* were also treasure troves of information.

There are a number of people I would also like to thank individually. These include Lorraine McConaghy, without whose class Nearby History this project would have been insurmountable; Anne Frantilla, librarian at Seattle Municipal Archives and childhood friend at whose house adjacent to Ravenna Park I spent many a happy hour; Eleanor Toews, librarian for Seattle Public Schools Archives; Sarah Canwell with University Village; Jay Milton with Ivar's (Kidd Valley); Diana Crane with Pacific Consumers Cooperative; Robin Hing with Children's Home Society; Mary Greengo and Tom Wagner with Queen Mary; and David Watkins with Ravenna Volvo.

In particular, I would like to thank those people who gave generously of their time and access to private collections, including Larry Taylor and Don Bowen at the Theodora, John McManus at McManus Shoes and Footcare Center, Bill and Kitty Wilson at Ravenna United Methodist Church, Eileen Paul, Peter Blecha, and Carol Kocher. Special thanks to my sister, Robin Reid, for helping to maintain our family collection and happy memories of our time at the house on Twenty-ninth Avenue NE.

I also wish to thank my editor at Arcadia Publishing and good friend, Julie Pheasant-Albright, for her expert guidance and assistance during the writing and production of this book and for calling me up one morning and informing me this would be my next project. Finally, I would like to thank my husband, Tony Hicks, and my children, Isabelle and Jack Burke, for their love and support, always.

INTRODUCTION

In our fast-paced, transient society, it is important to find ways to ground people to their community and give them a rich and well-developed sense of place. There is perhaps no better way to provide that continuity of experience than to provide residents with a visual history of their neighborhood. Visual images act on a visceral level, evoking a powerful presence that increases feelings of involvement and belonging. History builds community by raising the level of understanding among diverse people, developing connections to the past through artifacts, increasing knowledge of the past in order to make better informed decisions, and imbuing the familiar and everyday with a rich context of meaning.

Over 50,000 years ago, the melt-off of the vast Vashon Glacial Ice Sheet formed Lake Russell, which cut deep drainage ravines through the glacial fill in the area that was to become Ravenna. Green Lake remained and continued to empty into Lake Washington through the Ravenna ravine, with Ravenna Creek following the path now marked by Ravenna Boulevard. The land was covered by stands of tall Douglas firs. W. W. Beck, the original owner and developer of Ravenna Park and the surrounding town, gave it that name because the ravine reminded him of Ravenna, Italy, an area famed for its beautiful pine trees.

Beck came to the area on the Seattle, Lake Shore, and Eastern Railroad when it was extended up the eastern shore of Lake Washington from Seattle. He and his wife developed the land around the Ravenna station into town lots, built a gristmill, and set aside land for the Seattle Female College. They also fenced off part of the ravine and formed Ravenna Park. In 1891, the Rainier Power and Railway Company completed a streetcar line from Seattle to Ravenna. The tracks went up Fifteenth Avenue NE to the park and then on to the town of Ravenna. Ravenna Park became a popular destination for the residents of Seattle, and the Becks charged them 25¢ apiece to visit it.

The Town of Ravenna passed out of existence in 1907 when it was annexed by Seattle. Ravenna Boulevard had been constructed to run between Green Lake and Ravenna Park along the path of Ravenna Creek, following a recommendation in the Olmsted Plan of 1903. Developer Charles Cowen acquired the upper end of Ravenna ravine in 1906 and set aside eight acres for Cowen Park. He donated it to the city of Seattle the following year. In 1909, development of transportation for the Alaska-Yukon-Pacific Exhibition was a great impetus for development in the area.

From this point on, the area grew rapidly with the development of housing, schools, churches, and businesses. The area seemed to draw social reformers, with the Volunteers of America opening the Theodora, assisting husbandless women and their children, and the establishment of the Children's Home Society, devoted to child welfare. The overall disposition of the residents started to become apparent as time and again they resisted changes to the neighborhood that they felt would be detrimental to its environment, standards, or character. This intense community involvement, which some feel is linked to the high percentage of University of Washington faculty and staff who make the area their home, has continued over the years as residents have successfully blocked freeways, maintained the quality of the park, stopped the use of pesticides, saved historic architecture, and restored Ravenna Creek to its original path.

A Seattle native, I grew up in the house in Ravenna that my parents bought when they moved here in 1948. My neighborhood had once been an orchard, and in my childhood and even still today, everyone's backyard had different varieties of fruit trees. As a child, I used to pull my little red wagon up and down the street loaded with fruit to exchange with the neighbors. Now my children can continue this tradition as they are the third generation to live in this house. It is my hope that Ravenna residents will see themselves, the generations that came before, and the generations still to come contained and celebrated in these images.

One

PRIOR TO 1900
RAVINES, RAILROADS, AND BIG TREES

Before settlers came, the principal feature of Ravenna was the creek that drained Green Lake and emptied into Union Bay. Glacial melt-off formed the wooded ravine, and Native Americans lived in a village on the shore of Union Bay. In 1852, David "Doc" Maynard arrived in the area. Reportedly he named Seattle after his friend Chief Sealth, leader of the Duwamish and Suquamish tribes. Henry Yesler opened his sawmill in 1853, and in 1861, Washington Territorial University was established. By 1870, Seattle's population was 1,107.

The Ravenna area would have several owners before increasing in value in the mid-1880s when the Seattle, Lake Shore, and Eastern Railroad extended up the shore of Lake Washington from Seattle. By this time, Seattle's population had grown to 3,533. In 1887, George and Oltilde Dorffel were the owners. The area still possessed its old-growth timber, and they designated the ravine as a park, likely because the steep topography would make building problematic. Ravenna became a stop on the new railroad.

In 1888, Rev. William W. Beck and his wife, Louise, purchased 400 acres on Union Bay. They developed the property around Ravenna station and set aside 10 acres for the Seattle Female College. Beck also opened the Ravenna Flouring Company. The Becks fenced the ravine and opened Ravenna Park. They imported exotic plants and built paths, picnic shelters, and fountains. Admission was 25¢.

Washington Territory became Washington state in 1889, the same year as the Great Seattle Fire and the dedication of Calvary Cemetery. By 1890, Seattle's population had grown to 43,487, an increase of approximately 40,000 people in 10 years. The population of Ravenna in 1892 was 50. By this time, Ravenna also had a grocery store, general store, and post office. On July 17, 1897, the steamer *Portland* arrived in Seattle with "a ton of gold," a phrase coined by Erastus Brainerd, press agent for the Seattle Chamber of Commerce, and Beriah Brown Jr. at the *Seattle Post-Intelligencer*. Seattle's population and economy grew rapidly after this, as Seattle became the port that would supply the gold fields of Alaska and the Yukon.

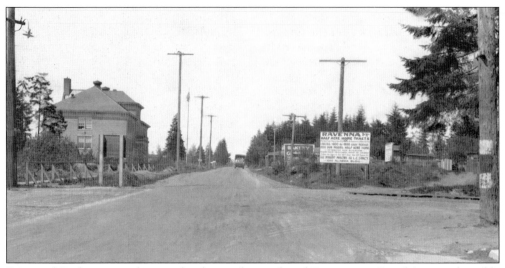

Reverend Beck was a real estate developer who marketed Ravenna as Seattle's most desirable suburb in the 1890s. He purchased 400 acres on Union Bay and developed the property around the Ravenna station of the Seattle, Lake Shore, and Eastern Railroad into town lots. This photograph shows the area around what is now NE Sixty-fifth Street and Ravenna Avenue NE with a sign offering half-acre home tracts. (Courtesy Jay Milton.)

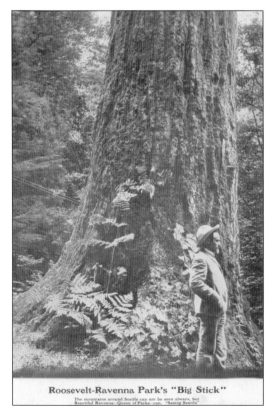

Roosevelt-Ravenna Park's "Big Stick"

The mountains around Seattle can not be seen always, but Beautiful Ravenna—Queen of Parks—can. "Seeing Seattle"

This poster of Beck shows him standing by "Roosevelt-Ravenna Park's 'Big Stick.'" The front states, "The mountains around Seattle can not be seen always, but Beautiful Ravenna—Queen of Parks—can." The back has a notation that says, "Uncle Wirt standing beside the Big Tree." In 1890, there was a sign on this tree that read, "measures 44 ft around, 18 in above the ground.'" (Courtesy Peter Blecha.)

A woman stands beside and appears to be partaking of Ravenna Park's mineral springs. At the time, there were over 40 springs in the park, including Mineral Spring, "already well known to visitors"; the Lemonade Spring near the big trees; Petroleum Springs in the center of the park; and a larger Mineral Spring in the upper creek bed. (Courtesy Peter Blecha.)

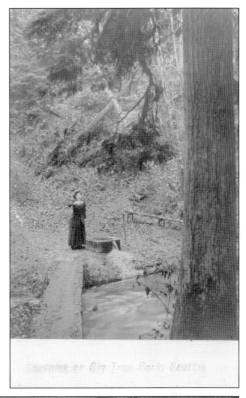

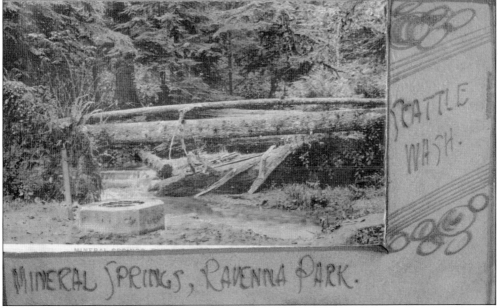

This glimpse of Mineral Spring was made into a postcard. The surround is made of leather with the words "Mineral Springs, Ravenna Park. Seattle, Wash." burned into it. The 1903 *Ravenna Park "Im Walde"* said, "Ravenna Park will . . . be the Kohinoor of parks to him who takes time to breathe its air, drink its waters, rest his eyes on its vegetation, and listen to the songs in trees and canyons." (Courtesy Peter Blecha.)

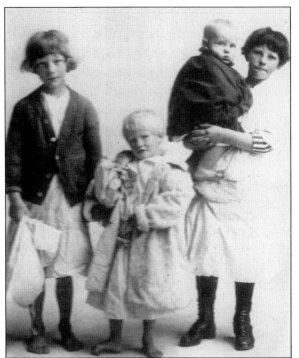

Just married and full of missionary zeal, if few financial resources, the Reverend Harrison Brown and his wife, Libbie, arrived in the Northwest in 1895 determined that the area's orphaned children find homes. *A Century of Turning Hope into Reality: A 100 Year Retrospective of Children's Home Society in Washington State* asks, regarding the children in this photograph, "Whence came these homeless waifs in the early years?" The most common disruptions in children's lives at the turn of this century were death, desertion, drink, and divorce. (Courtesy Children's Home Society of Washington.)

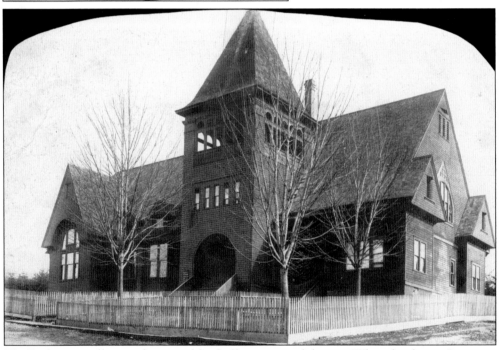

The Becks were college graduates and fond of literature and the arts. When developing Ravenna, they set aside 20 acres for the Seattle Female College. By 1890, there were 40 students studying art and music. Many thought the Becks were victims of bad timing, as the college closed during the Panic of 1893, and the University of Washington opened two years later nearby. (Courtesy Ravenna United Methodist Church.)

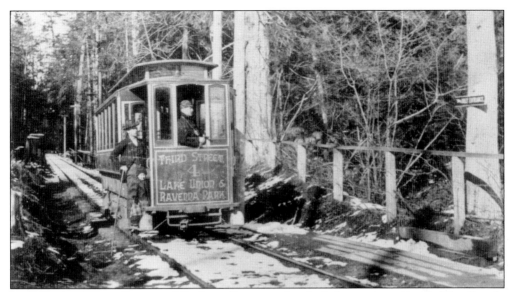

In 1891, the Rainier Power and Railway Company finished the streetcar line linking Seattle to Ravenna by way of a bridge across Portage Bay. The tracks ran up Fifteenth Avenue NE to the park, then followed the southern boundary to Ravenna. This 1895 streetcar, known as the "Ravenna Trolley," was headed to Third Street and South Ravenna near the entrance to the park. (Courtesy Peter Blecha.)

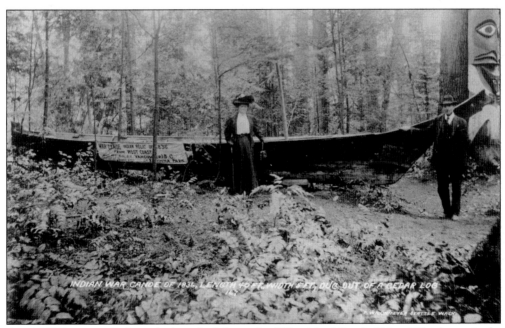

A c. 1909 Ravenna Park guide described this sight: "Aboriginal Battle Ship—Which required a whole tribe six months to dig out of a cedar log with stone tools; it was used for war, commerce, etc., and as a Model for the 'American Clipper Line.' It is seaworthy and a Great Relic." Forty feet long and five feet wide, it was in an "Indian Village where Totem Poles, War Canoe, and Tepees speak more than words can of the aboriginal life." (Courtesy Peter Blecha.)

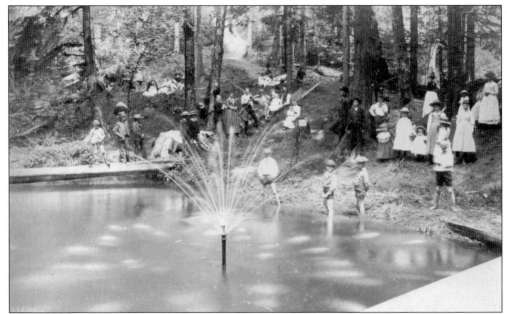

Pictured here are men, women, and children gathered for an outing in Ravenna Park *c.* 1889. In the creek is a man-made fountain. Clubs, churches, schools, societies, lodges, and other groups could use the park for one day at a flat rate of $10 per 100 people or less. Several people lounge in a hammock in the background, and a large camera sits on a tripod by the water. (Courtesy UW Special Collections.)

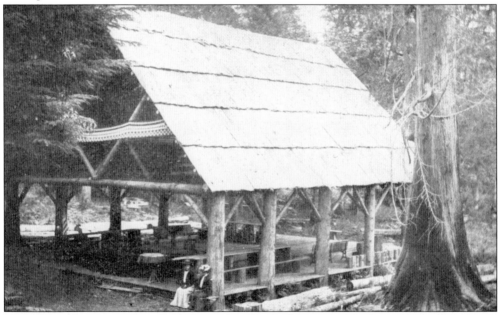

In *c.* 1909 guides written about Ravenna, or "Big Tree Park" as it was also known, several structures are mentioned, including Mountain View Pavilion, Basket Picnic Pavilion, Vidar's Hall, Squirrel Inn, and Rustic Pavilion, where "hickory rocking chairs, cheery log fire offer a welcome to all." Perhaps these women are resting from walking one of the many paths that included Rhododendron Way or the Walk of the Gods. (Courtesy Peter Blecha.)

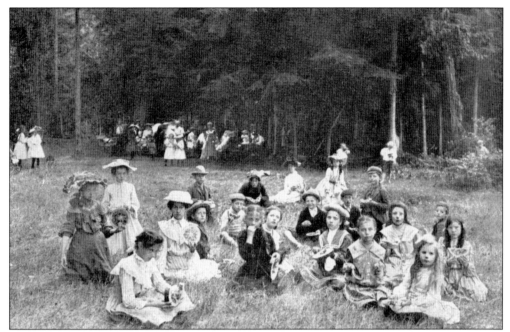

This group, gathered for a picnic in Ravenna Park, is enjoying watermelon on a summer's day. It could be the Methodist Churches of Seattle who held a great Reunion Day on July Fourth or any of the Presbyterian, Congregational, Episcopal, Baptist, or Catholic churches that also held festive days in the park. (Courtesy Peter Blecha.)

This photograph, taken by Anders Beer Wilse in 1898 of a covered facility for picnics at Ravenna Park, is entitled the "Picknick Ground." It may have been Wilse who was the photographer quoted as saying, "It cost 25 cents to get in Ravenna Park and I take $25 worth out." (Courtesy Seattle Municipal Archives [SMA].)

In 1869, Fr. Francis Prefontaine established Seattle's first Catholic church. Although Seattle had roughly 600 inhabitants, he was only able to find 10 people who professed to be Catholic. Calvary Cemetery, at what is now NE Fifty-fifth Street and Thirty-fifth Avenue NE, was the city's first Catholic cemetery. Before streets were graded, caskets and mourners traveled by train to Ravenna Station to reach the 40-acre burial ground. (Courtesy Ann Wendell.)

Burials at Calvary included persons known locally and worldwide such as Lt. Governor John Cherberg and Teamster Dave Beck. Veterans of both sides of the Civil War, as well as the Spanish-American War, World War I, and the Boxer Rebellion are also buried there. Many pioneer loggers belonged to Woodsmen of the World, and their motto—*dum tacit, clamat* (While he is silent, he shouts)—is inscribed on their tombstones. (Courtesy Ann Wendell.)

16

Two

THE 1900s
PARKS, PLANNING, AND AN EXPOSITION

In 1901, President McKinley was assassinated and Theodore Roosevelt was sworn in to office. Marconi would send the first radio message across the Atlantic. The paralyzing economic depression of the 1890s had lifted, and Seattle was coming into its own as a major rail and port city. By 1900, Seattle's population was 80,671. Ravenna and its neighboring districts were poised for growth. During this time, Seattle city engineers diverted Ravenna Creek into a sewer drain that discharged into Union Bay. Then on April 30, 1903, John Charles Olmsted arrived in Seattle, and based on his recommendation, Ravenna Boulevard was constructed to follow the path of the stream.

In 1903, Methodists formed a congregation in Ravenna, meeting in the main hall of the defunct Seattle Female College until it burned to the ground. In 1906, developer Charles Cowen acquired the upper end of the Ravenna ravine, west of Fifteenth Avenue NE. He set aside eight acres for Cowen Park and donated it to the City of Seattle the following year. In November 1908, Washington Children's Home Society opened Brown Hall. The society would become the largest private, not-for-profit child welfare organization in the state. The site on NE Sixty-fifth Street at Thirty-third Avenue NE has been the headquarters of the society ever since. By 1907, the separate town of Ravenna had ceased to exist by virtue of its annexation by Seattle.

In June 1909, the Alaska-Yukon-Pacific Exposition opened on the site where the University of Washington resides today, and development of transportation for visitors would continue to spark development in northeast Seattle. One hundred acres of old-growth Douglas firs were cut down to make way for the fairgrounds. When the exposition was being planned in 1908, the Becks allowed local clubs to name the largest trees, one of the park's prime attractions. The Becks called one Paderewsky after the Polish pianist who was a friend of Mrs. Beck, and Mrs. Beck named the tree with the largest girth Theodore Roosevelt. The tallest fir was named Robert E. Lee by the United Daughters of the Confederacy.

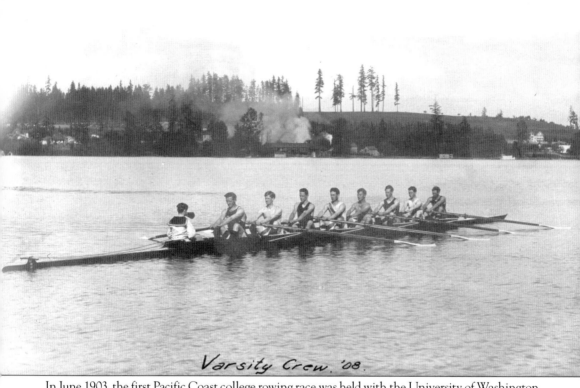

Varsity Crew, '08.

In June 1903, the first Pacific Coast college rowing race was held with the University of Washington (UW) defeating the University of California in one and a half miles. Student interest in rowing may have dated to 1895 when the UW moved from downtown Seattle to the campus between Lake Union and Lake Washington. Here the varsity crew of 1908 is shown on Lake Washington. On the shore behind them, evidence of extensive logging can be seen, and the smoke might well have come from the Seattle Flour Mills. The houses of Ravenna can also be seen. The year before, on January 15, 1907, the Town of Ravenna was annexed by the City of Seattle. The former fourth-class town ran for five blocks between Fifteenth Avenue NE and Twentieth Avenue NE and between NE Eighty-fifth Street to NE Fifty-fifth Street plus an area from Twentieth Avenue NE on the west and Thirtieth Avenue NE on the east and from NE Sixty-fifth Street on the north to NE Fifty-fifth Street on the south. (Courtesy Carol Kocher.)

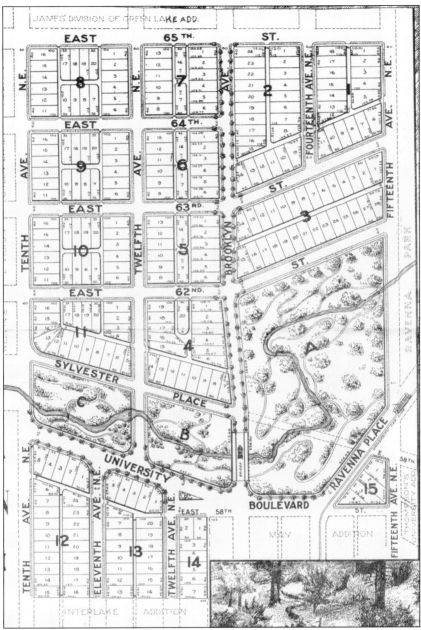

This map is from a booklet produced after the Alaska-Yukon-Pacific (AYP) Exposition took place and was meant to draw attention to "Cowen's University Park." Charles Cowen donated this park adjacent to Ravenna Park to the city in 1907. The AYP Exposition took place on the new grounds of the University of Washington, and one of its principal legacies was adding four permanent buildings and a landscaped campus to the institution. It showcased the resources of Washington State and included displays of agriculture, manufacturing, and forestry. A highlight of the exposition was the tours of the Big Trees of Ravenna Park. Ravenna was referred to as "Nature's Exposition," and a c. 1909 park guide said that "within one mile of the 'Forestry Building' (one of the most lavish and elegant buildings of the exposition) is a Forest Primeval." A Harvard man was quoted as saying, "It is the glorified 'Forestry Building' springing to life." (Courtesy Peter Blecha.)

Trevor Charles Digby Kincade, professor of zoology at UW, wrote extensively about the vegetable and animal life of Ravenna Park. He was quoted in the 1903 *Ravenna Park "Im Walde"*:

> The humming-bird darts with shrill flight-whirr through the thickets in search of tiny insects, while among the firs the bluebird, with its flashing plumage, glides from bough to bough. Squirrels and chipmunks chatter upon the hillsides as they gather stores of hazelnuts, while along the banks of the stream in secluded spots the showtl [a relative of the beaver] . . . burrows deeply into the earth to form his subterranean dwelling. At night the showtl comes forth, after the fashion of his relative the beaver, and carries on his modest lumbering operations. The stream flowing through the park forms a home for the trout and other small fish as well as for . . . aquatic insects . . . and several kinds of snails. In sunny glades the butterflies and bees hover about the blossoms of the plants . . .and keep company with golden-banded flower-flies.
>
> > I wind about, and in and out,
> > With here a blossom sailing,
> > And here and there a lusty trout,
> > And here and there a grayling.
> > —Tennyson's Brook

(Courtesy Peter Blecha.)

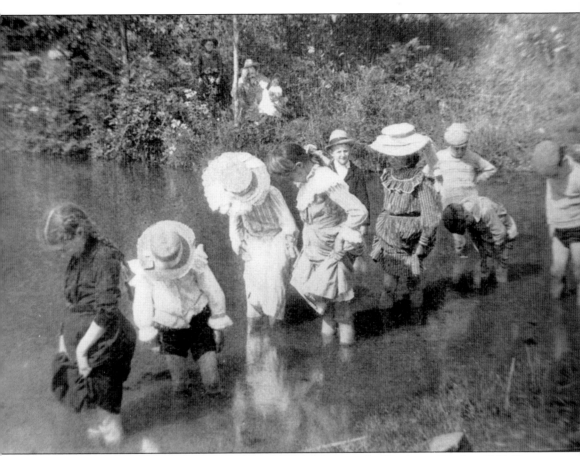

These happy Ravenna Park visitors, most likely a church group, ford Ravenna Creek in 1909. Five years earlier, the superintendent of parks wrote to the park board concerning park employees' wages. He mentioned they often had to do police duty on Sundays and suggested raising wages, bringing a park keeper up to $2.50 per day and a waterboy to $1.50 per day. (Courtesy SMA.)

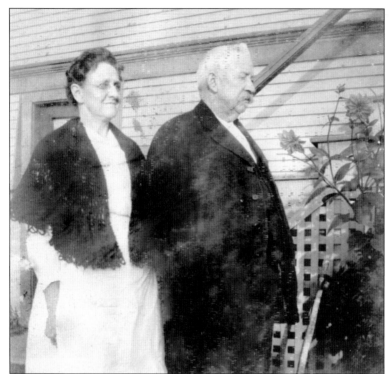

Richard and Katie Mueller, both born in Germany, moved from Cripple Creek, Colorado, to Seattle in 1903 on the advice of Richard's doctor, who told him the family should leave the high altitude for sea level. Richard's trade was a commercial merchant. The Muellers built their first house in Ravenna in 1908, another in 1919, and one for their daughter, Olive, in 1910 as a wedding present. (Courtesy Carol Kocher.)

This was Richard and Katie Mueller's first home, 1616 NE Sixty-fifth Street, built in 1908. Richard and Katie had five surviving children: Olive, Alvin, Karl, Moritz, and Myron ("Ferdi"). All the children, with the possible exception of Alvin, attended the University of Washington. Olive would be a wife and mother, Alvin became an auditor, Karl and Moritz were engineers, and Ferdi became an electrician. (Courtesy Carol Kocher.)

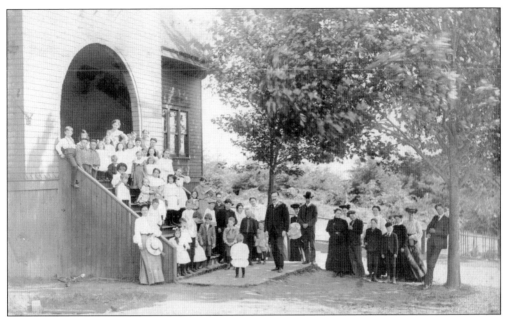

Ravenna United Methodist Church (RUMC) was founded in 1903. Its first Sunday school was located at NE Fiftieth Street and Thirty-sixth Avenue NE just north of the town of Yesler, which was a community that Henry Yesler founded for workers at his sawmill. Later that year, the congregation moved into the building pictured—the former Seattle Female College, which had shut down, and the building had been vacant since 1895. (Courtesy RUMC.)

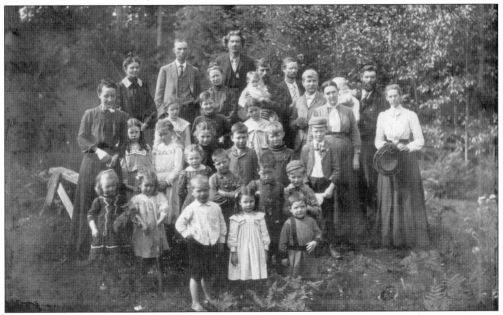

The Reverend H. J. Hartsell became the first pastor for the congregation of about 14 charter members of the Ravenna Methodists. They were able to come to terms on the sale of the building owned by Rev. W. W. Beck, and it became known as the "Red Church." The church prospered and started a full program of activities. The congregation is shown gathered here, most likely at Ravenna Park. (Courtesy RUMC.)

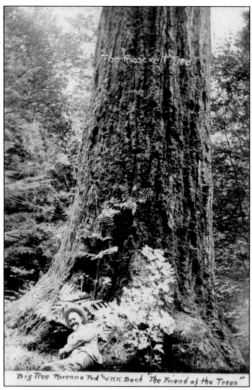

Big Tree Ravenna Park and W.W. Beck "The Friend of the Trees"

W. W. Beck is shown here in "Big Tree Ravenna Park" and is proclaimed "The Friend of the Trees." He continued to tirelessly promote the park, making sure everyone knew it was private property and that the admission price of 25¢ went to support owed taxes, which in 1909 topped $15,000. (Courtesy Peter Blecha.)

BEAUTIFUL SEATTLE. IN RAVENNA PARK

In this section of the c. 1909 Ravenna Park guide, the emphasis is on maintaining the park: "You may feel that it is a hardship, among the wealth of ferns and mosses, to pick none? If you are old enough to know the multiplication table, you can look at the many thousands of names in the visitors' register for last year and multiply it by even one fern, and see of what the park would be robbed by those who love it best!" (Courtesy Eileen Paul.)

24

Here is another example of Beck's justification of an admission fee for Ravenna Park: "And maybe you grumble a little over an admission fee? A newcomer might imagine this land taken up by its owners from the government, and swept but by 'Heaven's sweet air,' when, in fact, it represents in purchase price, interest, taxes, improvements and maintenance a cost of more than seventy thousand dollars. Now figure a little and see if you would keep it open gratuitously if you owned it?" (Courtesy Eileen Paul.)

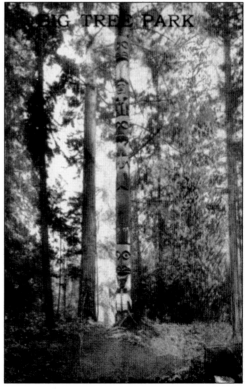

This postcard shows one of the six totem poles in Ravenna Park. There was less controversy about these totems than the 60-foot pole erected in Pioneer Square in 1899 that turned out to have been stolen from a Tlingit village in Alaska by a group of prominent Seattle citizens. The Tlingit tribe demanded $20,000 in payment, but settled for $500, which was paid by the *Seattle Post-Intelligencer*. (Courtesy Eileen Paul.)

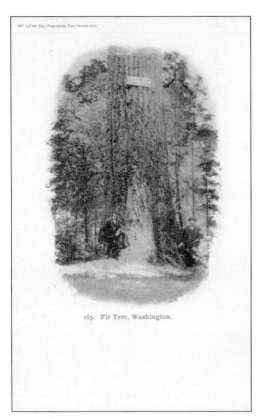

165. Fir Tree, Washington.

This image is one in a series of popular postcards from the time it was published. Enos Mills, forestry expert and one who, like W. W. Beck, was often referred to as "The Friend of the Trees" stated, "Ravenna Park is a ten-ringed circus, and those evergreen banners should never be furled." (Courtesy Eileen Paul.)

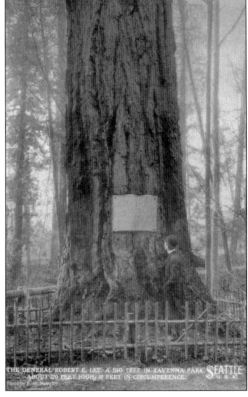

In 1908, in anticipation of the upcoming Alaska-Yukon-Pacific Exposition that would take place nearby, the Reverend and Mrs. Beck allowed local clubs to name the largest trees in Ravenna Park. The tallest fir, which rose nearly 400 feet, was named Robert E. Lee by the United Daughters of the Confederacy. (Courtesy Eileen Paul.)

The Paderewsky was named after the Polish pianist, a friend of Mrs. Beck. Ignace Paderewski was a popular speaker renowned for his wit as well as his virtuosity. When introduced to a polo player with the words "You are both leaders in your spheres, though the spheres are very different," he replied, "You are a dear soul who plays polo, and I am a poor Pole who plays solo." (Courtesy Peter Blecha.)

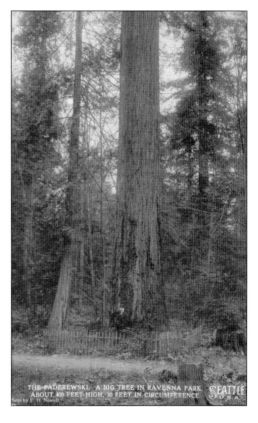

THE PADEREWSKI, A BIG TREE IN RAVENNA PARK, ABOUT 400 FEET HIGH, 30 FEET IN CIRCUMFERENCE

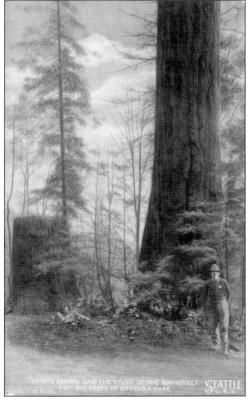

ADAM'S CROWN AND THE STUMP OF THE ROOSEVELT. TWO BIG TREES IN RAVENNA PARK

Mrs. Beck named the tree with the largest girth "Theodore Roosevelt," and it was said the president visited the park and whispered his approval. In 1913, it was reported that the Roosevelt had been cut down and made into cordwood. The park superintendent claimed it was decayed and looming over one of the principal parts of the park and was therefore dangerous. (Courtesy Eileen Paul.)

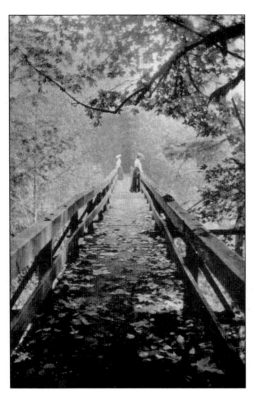

This 1903 picture is entitled "October Sear and Gold." *Ravenna Park "Im Walde"* (1903) states: "Ravenna Park is no longer a Summer park only. Clad in a mantle of snow it is a never to be forgotten sight. . . . The park may be seen at any season in comfort owing to the raising and draining of miles of old and new paths in the Canyon and Upper Park." (Courtesy Peter Blecha.)

609 BIG TREES, WASHINGTON.

This postcard dated 1907 was addressed to Mrs. B. J. Trueblood of Seattle. It shows a couple strolling on a wooden pathway through the park that appears, in places, to be suspended from the ground. The stump of one of the big trees can be seen in the foreground. (Courtesy Peter Blecha.)

This postcard is postmarked October 1, 1906, 7:30 p.m. The message reads, "Dear Etta: I thought I would show you some of the places around Seattle. Give my love to all the family. Write soon. Theresa and Will 1818 Sixth Avenue." As the sign on the tree states that it measures 44 feet around 18 inches above the ground, we can assume this is the one called the Roosevelt, Theodore Roosevelt, and Roosevelt's Big Stick. (Courtesy Peter Blecha.)

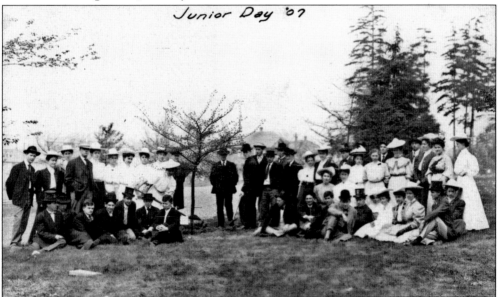

UW students are pictured on Junior Day 1907. This was the year that the groundbreaking for the Alaska-Yukon-Pacific Exposition took place at the southern end of the campus. Mandated by the Washington State Legislature, the exposition was to display the resources, products, and industry of the area. One hundred acres of old-growth Douglas firs were cut down in order to make way for the fairgrounds. (Courtesy Carol Kocher.)

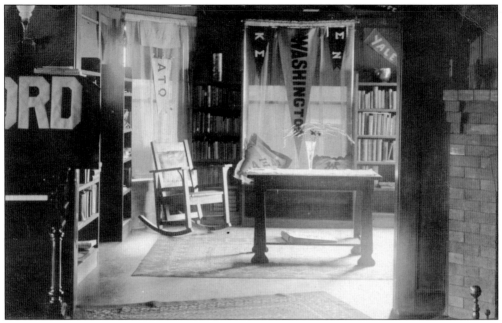

Olive Lillie Mueller Cumbo Walker was born in Berlin, Germany, on August 6, 1885, and moved with her parents to Seattle in 1903. She entered the University of Washington as a student in 1905. She was particularly proud that she was a charter member of the Nu Chapter of Alpha Xi Delta Sorority, the interior of which is shown here. (Courtesy Carol Kocher.)

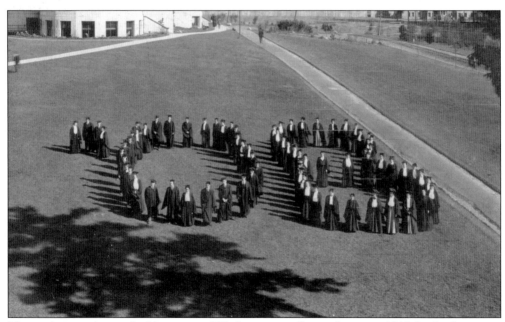

The graduating class at the University of Washington spells out their year, 1908, by the formation of their members on the ground. The picture was most likely taken from the top of one of the six buildings that made up the campus before the AYP Exposition. (Courtesy Carol Kocher.)

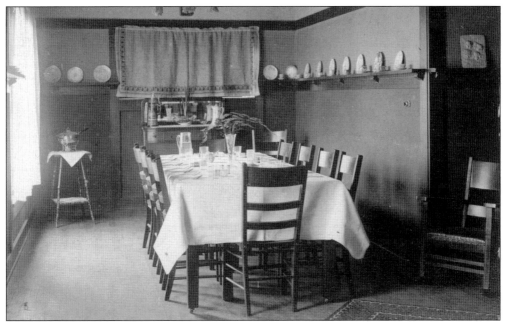

This photograph shows the dining room of sorority Alpha Xi Delta where the ladies would gather to eat their meals on fine china atop snowy-white tablecloths. A plate rack can be seen on the wall, which was typical of the Craftsman architecture of the period. (Courtesy Carol Kocher.)

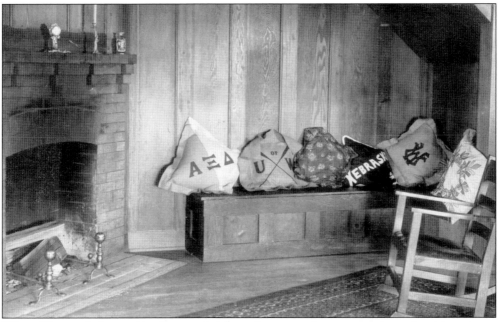

When Olive and George Cumbo married just a few years after meeting in geology class, it was the first wedding held of a woman from her sorority chapter. The sorority sisters helped with decorations, which included the sorority flower of pink roses. The sisters dressed in pink formals and formed an aisle for them to pass through, showering the couple with pink rose petals. (Courtesy Carol Kocher.)

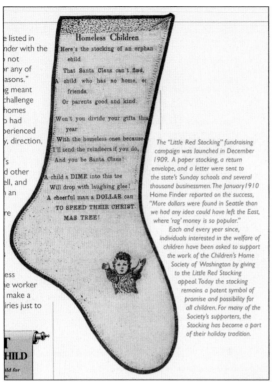

The Little Red Stocking fund-raising campaign of Washington Children's Home Society (WCHS) was launched in December 1909. A paper stocking, return envelope, and letter were sent to local businessmen and Sunday schools. The WCHS newsletter, *Home Finder*, announced in January 1910 that "More dollars were found in Seattle than we had any idea could have left the East." (Courtesy Children's Home Society of Washington [CHSW].)

Within the image:

e listed in
nder with the
not
r any of
asons."
g meant
challenge
homes
had
perienced
y, direction,

's
d other
ell, and
an

re

ess
e worker
make a
iries just to

Homeless Children

Here's the stocking of an orphan
child

That Santa Claus can't find,
A child who has no home, or
friends.

Or parents good and kind.

Won't you divide your gifts this
year

With the homeless ones because
I'll send the reindeers if you do,
And you be Santa Claus!

A child a DIME into this toe
Will drop with laughing glee!
A cheerful man a DOLLAR can
TO SPEED THEIR CHRIST
MAS TREE!

The "Little Red Stocking" fundraising campaign was launched in December 1909. A paper stocking, a return envelope, and a letter were sent to the state's Sunday schools and several thousand businessmen. The January 1910 Home Finder reported on the success, "More dollars were found in Seattle than we had any idea could have left the East, where 'rag' money is so popular." Each and every year since, individuals interested in the welfare of children have been asked to support the work of the Children's Home Society of Washington by giving to the Little Red Stocking appeal. Today the stocking remains a potent symbol of promise and possibility for all children. For many of the Society's supporters, the Stocking has become a part of their holiday tradition.

HILD
ld for

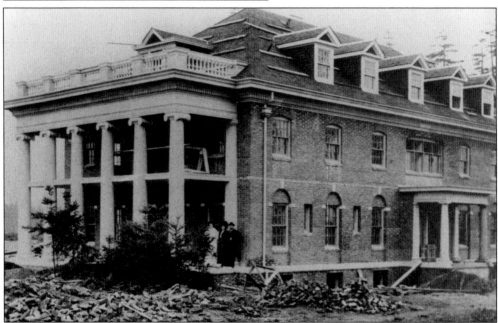

In 1905, Children's Home Society began to raise funds for a permanent receiving home for children. An acre of land was purchased in Ravenna Heights with money donated by M. F. Jones in 1906. It was not until fire destroyed their temporary home in 1907, killing two infants, that they received the community support necessary to build Brown Hall on the property in 1908. (Courtesy CHSW.)

Three

THE 1910s

WAR, WOBBLIES, AND NEW SCHOOLS

By the end of 1910, Seattle's population had grown to 237,194. Neighborhood growth continued with the Methodists building a small church at the southeast corner of NE Sixtieth Street and Thirty-third Avenue NE. It became known as the "Little Brown Church on the Hill" and enjoyed a panoramic view of Ravenna. The Coliseum, America's first grand movie palace, opened, and the first automobile ferry made its inaugural trip across Lake Washington. The Smith Tower opened to become the tallest building west of the Mississippi.

The Pacific Northwest had long been recognized as a center of labor radicalism. The Socialist Party of Washington had formed in 1901 and by 1912 was strong enough to elect city officials in Seattle. The Industrial Workers of the World (called Wobblies) also flourished in the cities and timber camps of the region. In 1919, Seattle shipyard workers were locked out of their jobs by order of the U.S. government in cooperation with their employers. Their response was the general strike of February 1919, which grew to include 65,000 union workers staying home in solidarity. It was regarded as the first general strike in the nation's history.

The United States entered World War I on April 4, 1917, and Seattleites went to work at the Bremerton Navy Yard. The next year, Seattle florists ran out of funeral flowers when the Spanish influenza pandemic struck in September. The *Post-Intelligencer* reported nearly 300 deaths statewide in the first six weeks. Seattle banned most public and private gatherings and closed schools, libraries, and theaters.

By 1920, Seattle's population would reach 315,312, and the Seattle School Board proposed a $3-million building for the Ravenna area. Many complained that the plans were too grandiose and expensive and the location too far out of the city proper. The groundswell of support grew, however, and construction of the building was ready for the 1922 school year. Within five years, Roosevelt High School had exceeded its capacity, and 11 more classrooms were added.

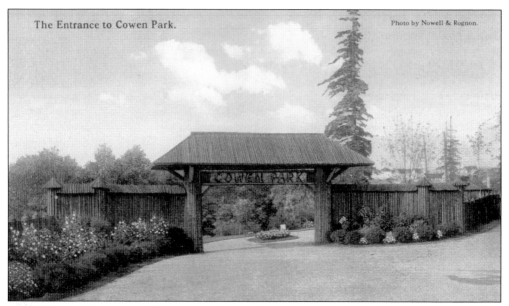

The Entrance to Cowen Park.

Photo by Nowell & Rognon.

A 1910 Parks Department Report noted regarding Cowen Park that "a rustic entrance has been constructed which adds greatly to the appearance of the park from the University carline. Considering its recent acquisition, Cowen Park is perhaps more nearly complete than any other park of the system, and it is being beautified along lines which have made it as attractive and as popular as it deserves." (Courtesy Eileen Paul.)

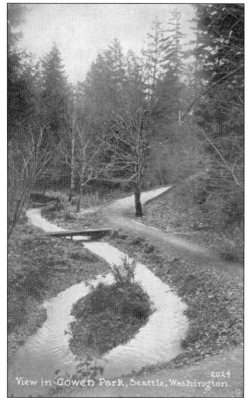

View in Cowen Park, Seattle, Washington.

The report went on to state that Cowen Park "contains about nine acres, being donated to the city in 1907 by Mr. Charles Cowen. It consists largely of a winding ravine with beautiful natural growth on its slopes, while a babbling brook course the ravine and affords a means of creating many charming effects." (Courtesy Peter Blecha.)

Beck sold Ravenna Park to the city in 1911 for $122,000. The interchange between Beck and the city had become quite acrimonious. In a 1911 letter, Beck states, "We will forego the few dollars the city by false swearing and tricks of Satan obtained the great park for and go to the Poor Farm before we will surrender our rights." (Courtesy SMA.)

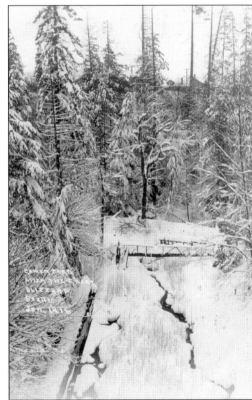

This postcard of Cowen Park after the great blizzard of 1916 carries the following note: "Hello Big Boy. How this for a scene—over 4 ft fall last winter. Great city. You would like it. One of the largest indoor rinks in the US. Hockey teams are all professionals. Come on up and take a skate with me. George." (Courtesy Peter Blecha.)

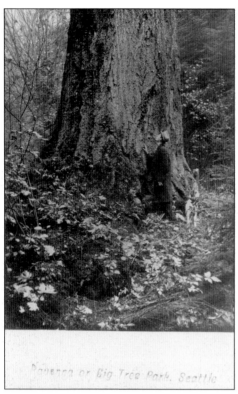

In February 1919, the park board met and discussed changing the name of Ravenna Park to Roosevelt Park. A Mr. Erwin, a park board member, said, "Ravenna Park seems the ideal park to bear his name. He was a lover of the wild and rugged and Ravenna is our only park preserved in that condition." The resolution passed, and the name was changed until residents demanded the original name returned in 1931. (Courtesy Peter Blecha.)

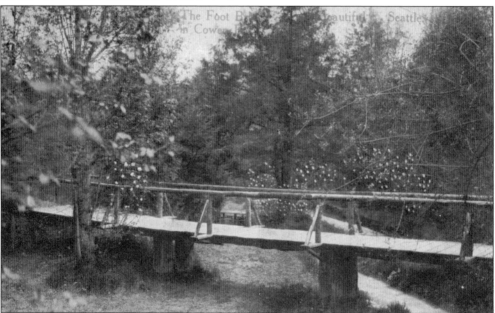

Cowen Park was named for Charles Cowen, who donated it to the City of Seattle. He requested that the inscription on the gatepost at the entrance of the park read, "Man does not live by bread alone." Born in England, Cowen spent his childhood at the family diamond mine in South Africa. He came to the United States on business and remained to form the Haynes-Cowen Real Estate and Insurance Company. (Courtesy Eileen Paul.)

The Fifteenth Avenue footbridge in Cowen Park is shown here in 1915. A few years later, the *Seattle Times* would carry a story of the "perilous acrobatics" of Ernestine Schmitt, a secretary, who slipped on the frosty bridge while running to catch the streetcar. She "there clung with numb fingers, suspended perilously over the deep ravine" until rescued by passersby. (Courtesy Peter Blecha.)

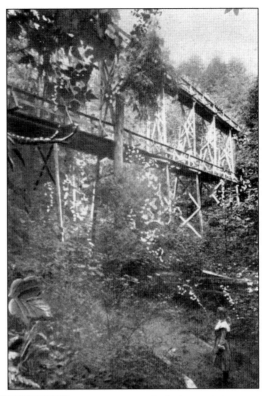

Ravenna Park derives its name from Ravenna, Italy, from whence "came Dante, wandering year by year dreaming of his beloved Florence, and drinking from the wild solitudes inspiration," noted the 1903 *Ravenna Park "Im Walde."* This 1915 photograph was obviously taken before the incidents of 1916, which prompted a letter complaining of the appearance of schoolboys with sling-shots resulting in the "disappearance of practically all of the song birds and quail." (Courtesy SMA.)

When George and Olive Cumbo returned from their honeymoon, it was to their new home next door to Olive's parents, Katie and Richard Mueller. Richard had the house built as a wedding present to "keep his Olive near them." A detailed accounting of the construction remains, listing such costs as $1 for a building permit, $4.75 for nails, and $18.35 for lumber for doors and windows. (Courtesy Carol Kocher.)

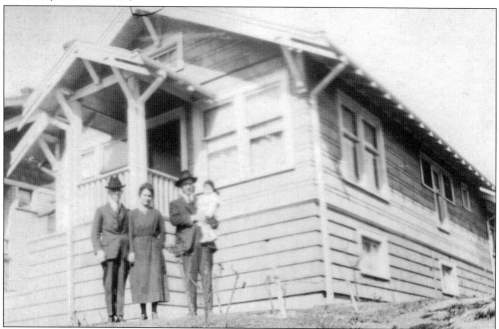

This photograph shows the second house that Katie and Richard Mueller built in 1919. The house was at 6528 Sixteenth Avenue NE. Standing in front of the house is their son Karl with his wife, Mary. Also pictured is Ferdi, another son of the Muellers, holding Karl and Mary's daughter Alice. Richard died at home the following year after an illness of seven months. (Courtesy Carol Kocher.)

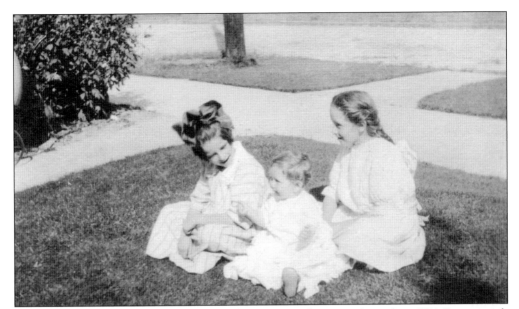

The three girls of George and Olive Cumbo sit across the street from their 6511 Seventeenth Avenue NE house. Mildred (left) was born in 1913, Marion in 1918, and Florence in 1911. At 10 months, Mildred contracted diphtheria from stroking a stray cat. The doctors said that her extended fever had injured some brain cells and left her with temporary paralysis and some signs of mental retardation. (Courtesy Carol Kocher.)

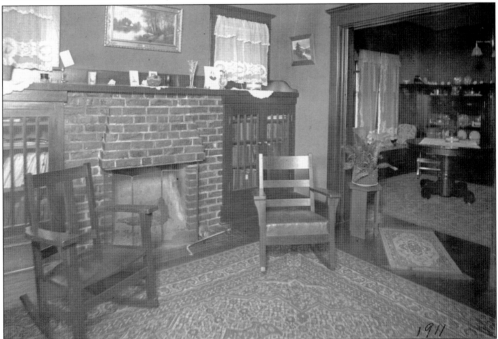

The interior of George and Olive's house is shown here in 1911. After their marriage, George bought enough furniture for them to start out, and with their many beautiful and useful wedding presents, they were able to be very comfortable. There are what appear to be two Morris chairs beside the fireplace and a pedestal-based table in the dining room. (Courtesy Carol Kocher.)

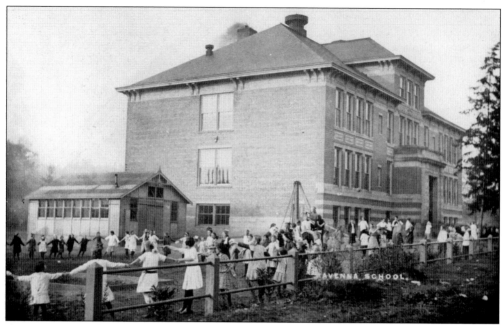

A one-room portable was built near NE Sixty-third Street and Twenty-second Avenue NE in the mid-1890s and named Ravenna. By 1908, there were almost 50 students. Because this property was small and poorly drained, another four-acre tract was purchased at NE Sixty-eighth Street and Twenty-second Avenue NE in 1909. This building was constructed and opened in fall 1911, although city limits didn't encompass it until 1923. (Courtesy Seattle Public Schools.)

When Florence Cumbo started Ravenna Grade School, her mother, Olive, began many years of leadership in the PTA. In the fall of 1916, the PTA produced a collection of *Favorite Recipes* that they sold for 25¢. Recipes from Olive and her mother, aunts, and sister-in-law are included. They most likely used the Crescent Baking Powder advertised in the cookbook since it was a local company. (Courtesy Carol Kocher.)

Although the Children's Home Society worked hard to help foster/adoptive parents have reasonable expectations of their new charges, placements were often unsuccessful. Some of the most common reasons for returning a child, from dirty faces to stealing, were listed in the 1913 *Home Finder* reproduced at right. (Courtesy CHSW.)

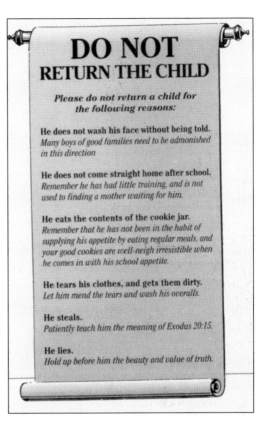

DO NOT RETURN THE CHILD

Please do not return a child for the following reasons:

He does not wash his face without being told.
Many boys of good families need to be admonished in this direction

He does not come straight home after school.
Remember he has had little training, and is not used to finding a mother waiting for him.

He eats the contents of the cookie jar.
Remember that he has not been in the habit of supplying his appetite by eating regular meals, and your good cookies are well-neigh irresistible when he comes in with his school appetite.

He tears his clothes, and gets them dirty.
Let him mend the tears and wash his overalls.

He steals.
Patiently teach him the meaning of Exodus 20:15.

He lies.
Hold up before him the beauty and value of truth.

The Ravenna PTA *Favorite Recipes* contained many advertisements for local businesses, most promising delivery or listing streetcar stops, as well as endorsements of politicians including sheriff and coroner. The undertaking parlors specify having a lady attendant available. There is also a note from the organizers reminding readers that "the concerns and individuals advertising in this book are worthy of our patronage and should receive it." (Courtesy Carol Kocher.)

Before-and-after pictures such as these of the children placed by Children's Home Society were often included in the *Home Finder* newsletter to both demonstrate the need for funds and to showcase the benefits of the society's work. The society's responsibility for the child did not end with placement. The children placed in foster homes were visited periodically by social workers until they reached adulthood. Having to perform a second placement for a child continued to be a problem. One of the main contributors to this was the inability to always adequately screen prospective parents. Prohibition provided some relief, lasting from 1916 to 1930 in Washington. The July 1919 *Home Finder* stated, "The closing of the saloon—which decreased the number of broken families, has no doubt . . . reduced the number of children received by the Society." (Courtesy CHSW.)

Four

THE 1920S
RADIO, WATER SKIS, AND BIG PLANES

City services continued to expand to the rapidly growing area, and the Methodists decided to sell the land under the Little Brown Church on the Hill to the Seattle School District. Bryant Elementary School now sits on this property. The church building itself was sold to the Roman Catholics and moved to where Assumption Catholic Church now resides. Across the nation, Prohibition began. Seattle's Japantown blossomed with 7,800 residents. During this time, one Japanese family opened a wholesale fern nursery that would later become a neighborhood landmark—Saxe Floral on NE Sixty-fifth Street.

During the 1920s, the nation's first radio broadcasting stations were opened. One of the earliest to operate in Western Washington belonged to Ravenna resident Vincent Kraft, who began broadcasting from his family's garage at 6838 Nineteenth Street NE. Although he didn't have a regular schedule, he broadcast to the surrounding neighborhood with records and occasional live music. On March 9, 1922, the Ravenna garage radio station was awarded the call letters KJR. KJR went on to become the number-one top-40 station in Seattle during the 1960s and 1970s.

In 1926, Bertha Landes became mayor of Seattle and the first woman to be mayor of a major U.S. city. Don Ibsen, a senior at Roosevelt High School, screwed a pair of tennis shoes onto a cedar board and became one of the inventors of water-skiing. This same year, the Seattle Parks Board contracted to have the last of Ravenna Park's giant trees felled because they were "rotten at the heart and for safety reasons had to be removed." This brought protests from the community and from former owner William Beck. Soon all the great trees were gone.

In 1927, Charles Lindbergh flew from New York to Paris in the *Spirit of St. Louis*, made almost entirely of Western Washington spruce. Boeing Field opened in 1928, and Thomas Edison flipped a switch in New Jersey and turned on Seattle's new electric streetlights. The United States' stock market crash hit in October 1929, and the nation spiraled into the Great Depression.

The Volunteers of America obtained an old mansion near Thirty-fifth Avenue NE and NE Fifty-sixth Street in 1914 and, according to rumor, named it the Theodora after a Theodore who was born on the property. Their work turned to social service, and it became a home for abandoned women and their children. Other activities included a soup kitchen, thrift stores, and a summer camp for children from low-income families. (Courtesy the Theodora.)

Here is the prosperous Cumbo family on their street in Ravenna. Although he is not pictured here, husband and father George worked as a chemist for the City of Seattle and provided well for his family. Just a few blocks away, families that looked very much like this but did not have the benefit of a male head of household were living at the Theodora. (Courtesy Carol Kocher.)

In this photograph, taken sometime in the 1920s, is the interior of a room at the Theodora. Women, who for reasons such as widowhood or abandonment did not have husbands, were provided with room and board, day care for their children, job training, and assistance in obtaining new housing. (Courtesy the Theodora.)

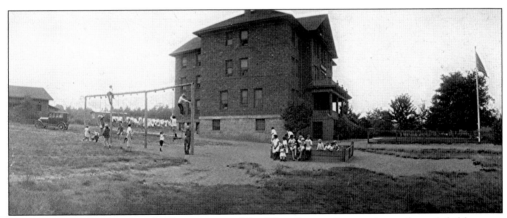

In another 1920s photograph, the exterior of the Theodora is shown. A number of children are playing on the grounds, some in a large sandbox and many clambering over the swing sets. A couple of adults appear to be watching over them. In the background is a large amount of laundry drying on clotheslines, and parked on the edge of the property is a Model T Ford. (Courtesy the Theodora.)

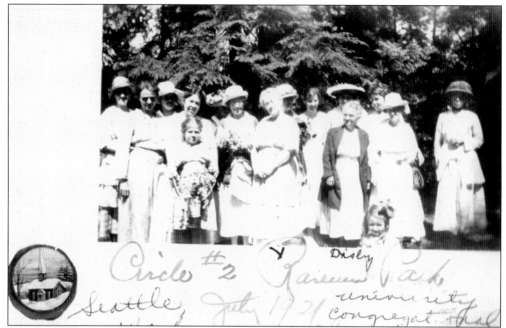

This photograph, most likely used as a Christmas card as evidenced by the image of the snow-covered church in the bottom left corner, shows Circle No. 2, a women's auxiliary club of University Congregational Church. Taken on July 19, 1921, it shows their annual picnic held in Ravenna Park. (Courtesy Carol Kocher.)

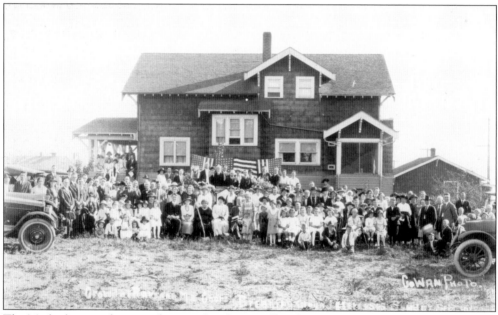

The Methodists are shown at the new church groundbreaking ceremony on September 10, 1922. The church was growing, with the Ladies Aid increasing from 18 members in 1922 to 63 in 1923. Their monthly meetings often opened with a hymn, followed by stories, games, and the occasional performance by girls from the Bryant School Orchestra. The 1922 bazaar netted $103.18, despite disagreeable weather and snow-covered ground. (Courtesy RUMC.)

46

Marion Cumbo, almost four years old, poses in front of her house at 6511 Seventeenth Avenue NE on the Fourth of July 1921. This was the also the year C. G. Anderson purchased the North End Transportation Line and turned it into the Seattle Motor Coach Company, serving Greenwood and Seattle. (Courtesy Carol Kocher.)

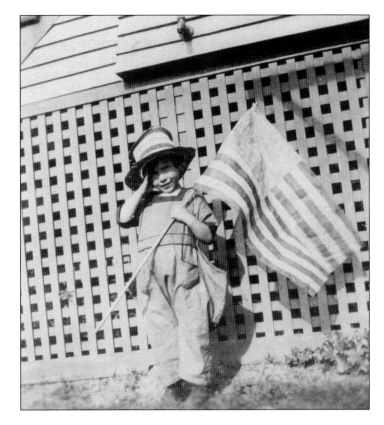

In this charming photograph, Marion Cumbo joins three other girls in portraying jonquils for a church performance at University Congregational Church in 1927. That year, Seattle was blessed by a visit from "Lucky Lindy" Charles Lindbergh, which drew 900,000 people. Elsewhere Babe Ruth made his 60th home run, setting a new Major League record. (Courtesy Carol Kocher.)

Florence Cumbo (seventh from left) poses with her girlfriends, many of whom sport bobbed hair, at her birthday party in the early 1920s. Her little sister Marion is at the front of the line. The large stately homes of the neighborhood can be seen behind them. (Courtesy Carol Kocher.)

Florence Cumbo is ready for winter play on her sled in her backyard. It's likely that she's riding on a Flexible Flyer, which enjoyed great popularity between 1910 and 1930. Sledding was usually called "coasting," and Seattle, especially Ravenna, boasted many hills that would have tempted neighborhood children. (Courtesy Carol Kocher.)

Marion, in a reminiscence written for her grandson, talked of her first toys and games. One was a metal scooter with a brake, as well as a four-wheeled car that she "pumped" around the neighborhood. Here she appears to be on one of her first tricycles. She also talked about a game called "Caroms" where players tried to hit round counters into corner pockets. (Courtesy Carol Kocher.)

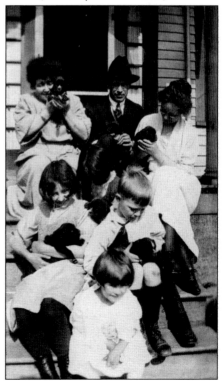

This group of people in the early 1920s struggles with an entire litter of puppies as they sit on a front porch. Rin-Tin-Tin became the most famous dog in the movies in 1923—it's likely one of these puppies might have been named after him. Other popular dog names of the time included Ruff from *Hi and Lois* and Sandy from *Little Orphan Annie*. (Courtesy Carol Kocher.)

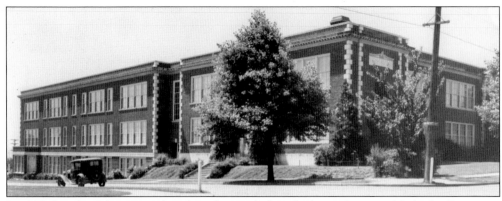

In 1925, the school district purchased two lots, including the former Ravenna Methodist Protestant Church. Construction of Bryant, a 20th-century Georgian building, was completed in 1926. Designed by Floyd Naramore, it had a flat roof with raised parapets and was faced with red brick with terra-cotta detailing. The Ford Model A Tudor sedan parked on the street was first produced in 1927. (Courtesy Seattle Public Schools [SPS].)

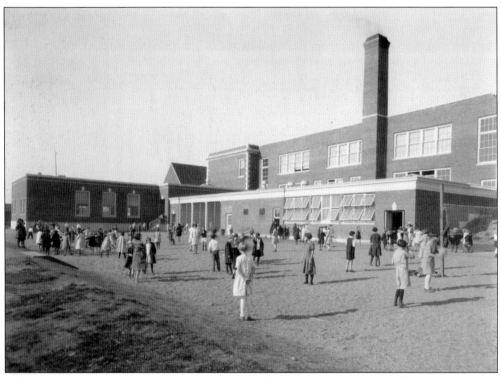

When Bryant first opened for the 1926–1927 school year, visitors came from all over to marvel at the indoor plumbing. It had toilets inside and sinks in the kindergarten, art, and science rooms. Indoor plumbing in the schools was not a new thing at this time, but to those who had had to tolerate the old wooden building's outhouses, it must have seemed the ultimate in modernity. (Courtesy SPS.)

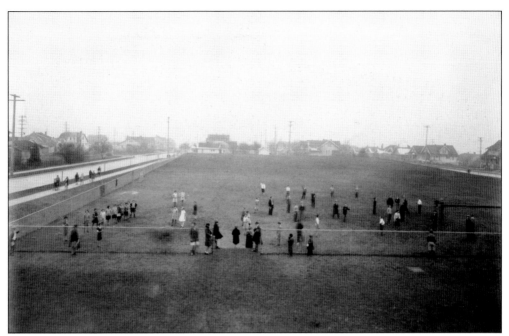

The playfield at the rear of Bryant Elementary, most likely pictured soon after its opening in 1926, clearly shows the surrounding neighborhood. The area's population was booming, and most of the houses that now stand around the school and south of NE Sixty-fifth Street were built in the 1920s. (Courtesy SPS.)

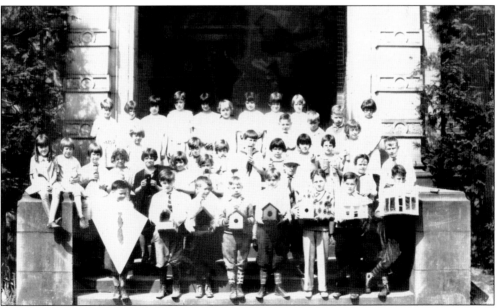

While some of the children of the Ravenna school appear to be holding art projects and one holds a kite, most have been participating in the school's birdhouse building contest. While this photograph most likely was taken in the 1920s, newspaper accounts from the 1940s still talk about the annual contest, which was said to be held to encourage nest building in the vicinity of the school. (Courtesy SPS.)

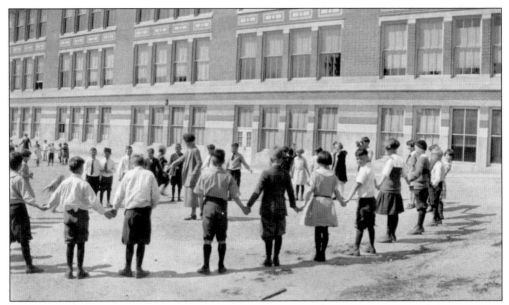

Students at the Ravenna school wait for instruction from a teacher during supervised play sometime in the 1920s. By 1923, Ravenna's enrollment was approaching 500 students, and a south wing containing 11 classrooms and an auditorium was added. The playground was also enlarged when two more acres to the west were purchased. (Courtesy SPS.)

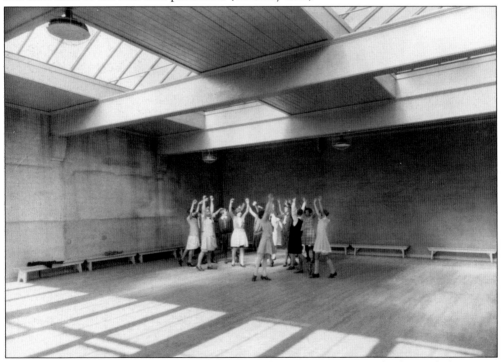

The girls of Bryant Elementary School engage in rhythmic exercise in the covered play court. Rhythmic exercise, influenced by the poise and balance of the ancient Greeks, was very popular in the 1920s and was felt to increase both health and beauty. While not dressed in gym suits, many of the girls do appear to have bloomers peeking out from under their skirts. (Courtesy SPS.)

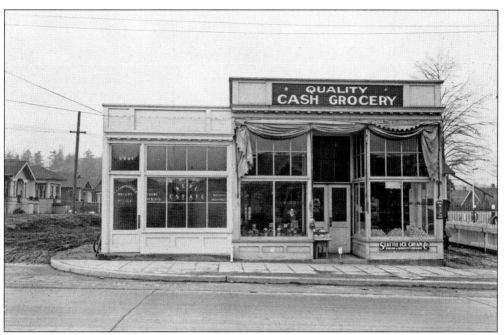

This photograph from January 27, 1922, shows the corner of E Fifty-ninth Street and Tenth Avenue NE. A store called Quality Cash Grocery is the main business, and a sign for Seattle Ice Cream Company is prominently displayed. Next door is notary public C. A. Christopher, who also appears to handle real estate rentals and loans. The side street is clearly unpaved. (Courtesy SMA.)

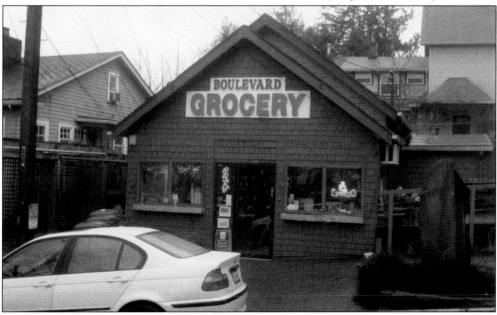

This modern photograph shows the Boulevard Grocery, which has stood at its location on 2007 NE Ravenna Boulevard since the 1920s. In 2004, the store proved its value with a YMCA Neighborhood Matters Recognition as a "Treasure to Ravenna that is helping to build strong neighborhoods and strong communities." Resident artists display their work there, and each year, the store runs an art competition for local kids. (Courtesy Julie Albright.)

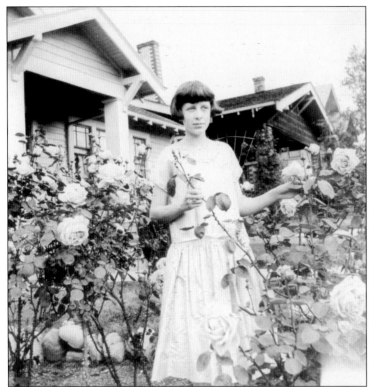

Marion Cumbo is shown in front of her house in 1923. She stands surrounded by rose bushes, which were her father's pride and joy. George may have continued to be inspired by the Seattle Civic Rose Garden in Woodland Park, which was completed in 1924. When the garden opened, it encompassed 1.8 acres and exhibited 150 varieties of roses. (Courtesy Carol Kocher.)

This unassuming little house at 6838 Nineteenth Street NE is the site of the first radio station to broadcast in Washington. Vincent Kraft started broadcasting from his family's garage sometime in 1920. It was claimed that he was one of the first broadcasters in the area to use vacuum tubes. On March 9, 1922, the Ravenna garage radio station was awarded the call letters KJR. (Courtesy Ann Wendell.)

These townhouses got their start as a wholesale fern nursery started by a Japanese family in the 1920s. It extended from NE Sixty-fifth Street to NE Sixty-eighth Street. When Louis Javete heard in 1947 that old Dr. J. N. "Doc" Saxe, a Seattle dentist, wanted to retire, Javete bought the business and grew it into a nationally known floral business. When Louis died in 2000, the family decided to expand the building into apartments. (Courtesy Ann Wendell.)

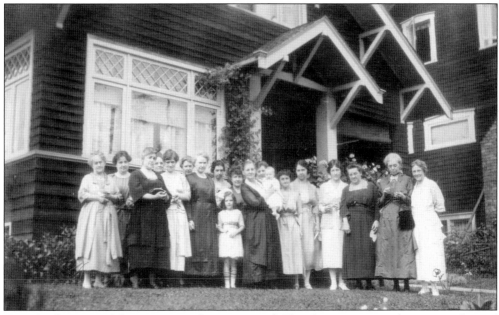

Here Circle No. 2 of the University Congregational Church meets again, this time in front of a member's house in Ravenna. The ladies group was a backbone to the church with members visiting the sick, conducting socials, sewing and knitting for charitable causes, and acting as an informal welcome wagon to newcomers. (Courtesy Carol Kocher.)

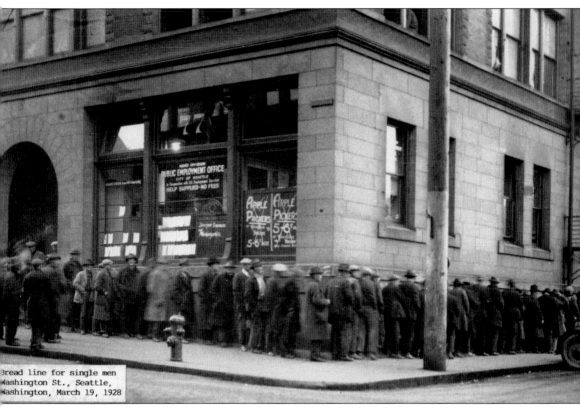

Bread line for single men
Washington St., Seattle,
Washington, March 19, 1928

This photograph of the bread line for single men at the Public Employment Office on Washington Street in downtown Seattle was taken on March 19, 1928. Ravenna residents most likely heard of the stock market crash of 1929 when newsboys ran through the streets, including residential neighborhoods, yelling, "Extra! Extra!" Marion Cumbo stated that everyone would run out to see if they could hear the news for free, but generally they had to pay a nickel for a paper if they wanted the details. She also remembered that her first awareness of the Depression was seeing her mother cry when their neighbors, the Priems, lost everything they had in the stock market. The Cumbos were luckier than many as they had a friend who worked for the Federal Reserve Bank, and he would cash the warrants her father received as payment from the city. The family also lived as economically as they could, canning fruit and vegetables purchased from the market on NE Sixty-fifth Avenue and NE Roosevelt Way and receiving 50 pounds of smelt from relatives in Longview. (Courtesy the Theodora.)

Five

THE 1930S
HOOVERVILLE, TAVERNS, AND KEEPING CLAM

By 1930, Seattle's population reached 365,583. It was estimated there were 300 to 500 Communist party members in Seattle, although police chief Louis Forbes stated he thought Seattle area members might be 500 and added that about half were "foreign stock," mostly Finns and Russians. By 1930, lumber production in Western Washington had fallen by more than 25 percent, and coal mining had declined by nearly 12 percent. Historians believe there were between 40,000 and 55,000 people out of work in Seattle by the spring of 1932. In the face of adversity, the Ravenna Methodist's Ladies Aid kept up their activities such as calling on the sick, holding bake sales, and attending the General Aid Picnic in Ravenna Park. When exchanging Christmas gifts amongst themselves, they were not to exceed 10¢.

In 1932, Franklin D. Roosevelt was elected president, and soon after, Adolf Hitler became chancellor of Germany in 1933. By 1934, the Seattle Census showed 632 men and 7 women living in 479 shanties in Hooverville. Despite the Depression, some local businesses got their start during this time. Eddie Bauer invented the down parka, Lloyd and Mary Anderson formed a buying co-op for climbing equipment that would become REI, and Ivar Haglund opened his first fish and chips stand on Pier 54. The year 1934 also saw the establishment of the Blue Moon Tavern in the University District and the Duchess Tavern in Ravenna. The taverns were extremely popular with students, who, under state law, had to go at least one mile from campus to buy a beer.

Ravenna was the scene of several projects by the Works Progress Administration (WPA) during this time. Unemployed men could be seen performing maintenance work in Ravenna Park. In 1936, the WPA built the Cowen Park Bridge, an art deco–style bridge over Ravenna Creek. It remains today as part of Fifteenth Avenue NE at NE Sixtieth Street.

The boys in this photograph are from the Volunteers of America's program for the unemployed. The year is 1931, and they are performing maintenance work in Ravenna Park. At Children's Home Society, a worker was placed by the WPA to lead teenage boys in recreational activities and manual training. It was reported the boys turned out some nice work in the workshop outfitted by the Engineer's Club. (Courtesy SMA.)

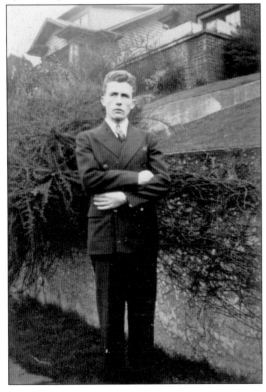

Paul Kocher had this photograph taken to be used with job applications in May 1939. Men's suits bought before the war typically came with jacket, vest, and two pairs of matching trousers. (Courtesy Carol Kocher.)

Organizations such the Boy Scouts were popular in the 1930s (and still meet at Bryant Elementary School). A scouting overnight trip during this time consisted of a hike from Bryant to Big Rock, a massive boulder and area landmark located on what is now Twenty-eighth Avenue NE near NE Seventy-second Street. (Courtesy Carol Kocher.)

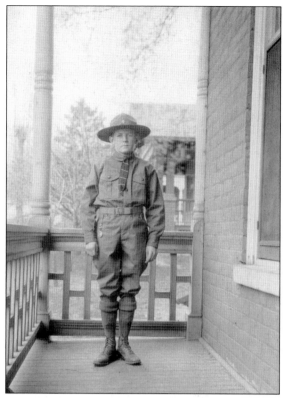

It's easy to imagine these happy-go-lucky schoolboys pretending to be Sick's Stadium announcer Leo Lassen, also known as "the Great Gabbo." Schoolboys throughout the city performed Leo Lassen routines for stunt nights, creating their own "Lassenisms," but it was hard to beat Lassen's own turns of phrase like "Mount Rainier is a big ice-cream cone over Franklin High tonight, folks" and "Hang onto those rocking chairs." (Courtesy SPS.)

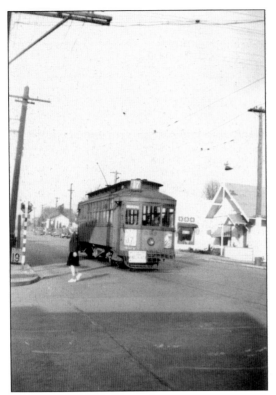

This streetcar, *c.* 1939, is the one the Cumbos rode to leave the neighborhood. It reads No. 17, Fifteenth Avenue NE (Cowen Park). As many people at this time either didn't have cars or money for gasoline, the streetcars were very popular. (Courtesy Carol Kocher.)

The first indication that streetcars might be on their way out came in 1932 when the state built Aurora Bridge without streetcar tracks. Then, in 1939, the Seattle-Everett interurban service ended. At the time, Seattle voted to retain streetcars but national automakers blocked needed financing. By 1940, the federal government loaned Seattle $10 million to retire its streetcar debt and fund a new bus and trackless trolley system. (Courtesy Carol Kocher.)

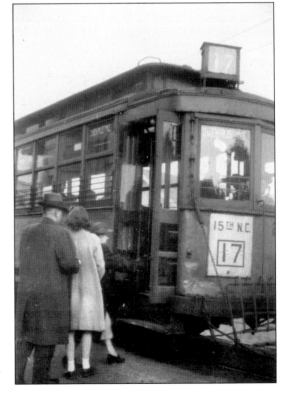

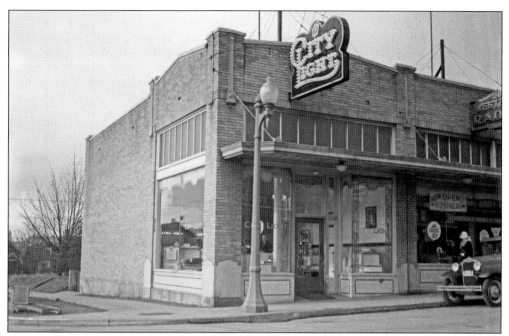

On March 10, 1931, Mayor Frank Edwards fired Seattle City Light superintendent James D. "J. D." Ross for "inefficiency, disloyalty and willful neglect of duty." He was fired reportedly on a dare after a party. The following day, the Municipal Utilities Protection League, a citizens' group based in the North End of Seattle, began circulating a recall petition against Edwards. Only 25,000 signatures were needed, but they gathered 200,000. This 1933 photograph shows a City Light retail store on Tenth Avenue NE and E Sixty-fourth Street offering appliances. (Courtesy SMA.)

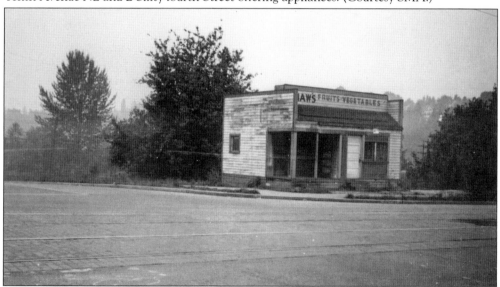

This fruit and vegetable stand by Ravenna Park in 1935 appears very isolated. Trolley tracks are evident in the cobblestone street. During this time, it was common for fruit and vegetable men to come to the neighborhood in their trucks. They would have a certain day of the week for each neighborhood and would treat good customers to an extra ear of corn or handful of beans. (Courtesy of SMA.)

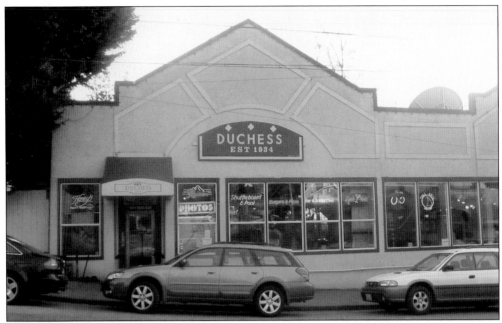

The Duchess Tavern, established in 1934, was one of the first taverns, like the Blue Moon in the University District, that took advantage of state laws that said alcohol sales must be at least one mile from the University of Washington campus. While the Blue Moon gained a reputation as a haven for artists and writers, the Duchess became the unofficial home of the various Husky sports teams. (Courtesy Ann Wendell.)

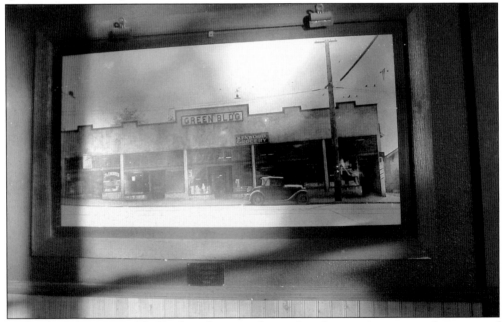

In this dimly lit corner of the Duchess, between the men's and women's restrooms, hangs one of the few remaining photographs of the Duchess taken in the 1930s. In it, the Duchess shares space in the Green Building with the Kenwood Grocery. A wall was built in the building to create the Beer Parlor and Restaurant, and children were allowed in until 1936. (Courtesy Ann Wendell.)

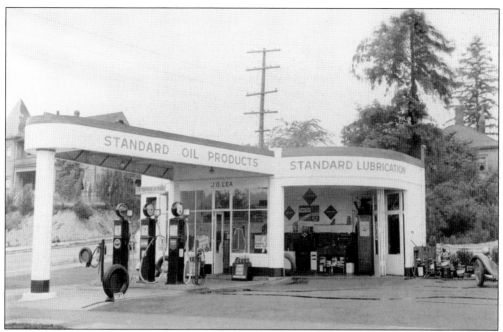

This photograph from the 1930s shows a Standard Gas Station at the corner of Twenty-fifth Avenue NE and NE Fifty-fifth Street. The basic structure of the building has remained in later incarnations as first the Dari-Delite and then Kidd Valley restaurants. The large Victorian house visible in the left-hand side of the image remains almost unchanged today. (Courtesy Kidd Valley.)

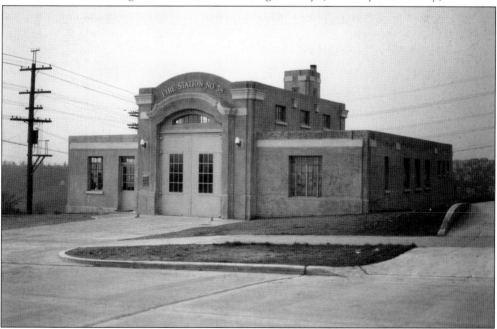

Fire Station No. 38 at the corner of Thirty-third Avenue NE and NE Fifty-fifth Street is only 2,700 square feet. Built in 1930, it is listed as a historic building. That may, however, be working against it as there are limits as to how much it can be renovated and many feel it is not earthquake safe or sufficient for larger rigs. In 2007, it is under consideration to be relocated. (Courtesy SMA.)

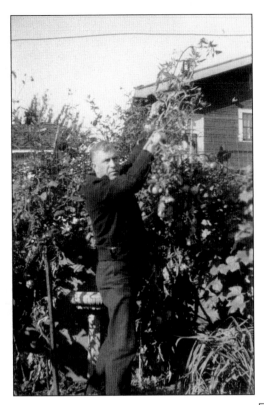

The caption on this photograph reads "George and his tall tomatoe [sic] plants (1938)." During the 1930s, Olive canned these tomatoes using a hot water bath as it was before the family had a pressure cooker. It would not be until the next year that the first commercial pressure cooker debuted in the United States at the New York World's Fair. (Courtesy Carol Kocher.)

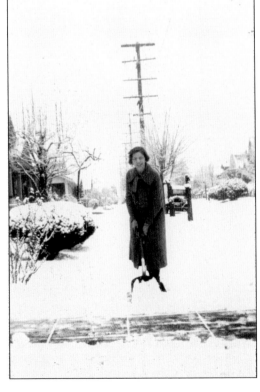

This photograph shows Marion Kocher in the winter of 1937 shoveling snow on the sidewalk outside their house. This must have been a terrible time for the men living in lean-tos made of tin or wooden crates in Hooverville on the Duwamish River. They would gather around old stoves or open fires to try and stay warm and dry. (Courtesy Carol Kocher.)

John Kocher, son of Marion and Paul, at 16 months rides his tricycle around the neighborhood on August 6, 1939. He appears to be ready for a Seattle summer by being bundled up like an Eskimo. (Courtesy Carol Kocher.)

Here Marion stands on the family's back porch in 1930 with her pet rooster on her shoulder. Her sister Florence had brought home a hen and rooster that they named Dotty and Scotty, respectively. Marion helped her dad build them a house, and they locked them in every night. Around 4:00 a.m., Scotty would start to crow, which didn't make them very popular with the neighbors. (Courtesy Carol Kocher.)

This 1937 photograph of room 7B at Bryant Elementary School was taken by Frank Perkins of 548 N Sixty-eighth Street. There is one student who appears to be of Asian descent. By the 1920s, Japanese farmers supplied 75 percent of the vegetables and half of the area's milk supply. Some historians believe fear of that success led to the passage of the Alien Land Law in 1921 to restrict property ownership. (Courtesy SPS.)

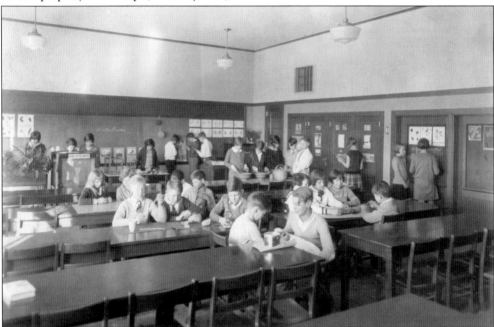

Students at Bryant are shown here in science class where they are completing projects related to water birds. The classroom is clearly in the new building that was completed in 1926. This building incorporated many aspects of cutting-edge school design, such as combined assembly/lunchrooms, covered play courts, and specialized staff rooms such as a nurse's office. (Courtesy SPS.)

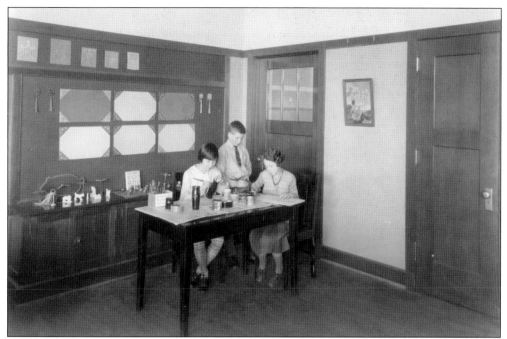

The children in the art room at Bryant Elementary School work on transforming tin cans into beautifully painted vases. Clothing and hairstyles seem to indicate that this is in the late 1920s or early 1930s. A print of Maxfield Parrish's *Air Castles* can be seen hanging on the wall above the children, no doubt meant to encourage artistic inspiration. (Courtesy SPS.)

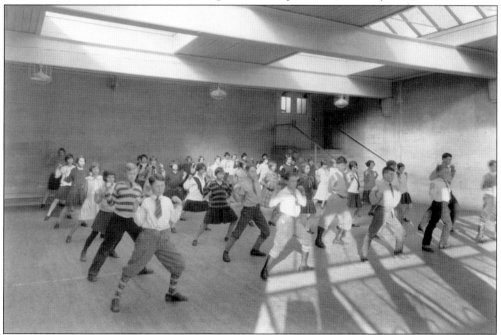

A gym class at Bryant Elementary School, *c.* 1930, was somewhat surprisingly coeducational. Some girls wear middy blouses, and a few boys sport long pants, although the majority of them are wearing knickers. (Courtesy SPS.)

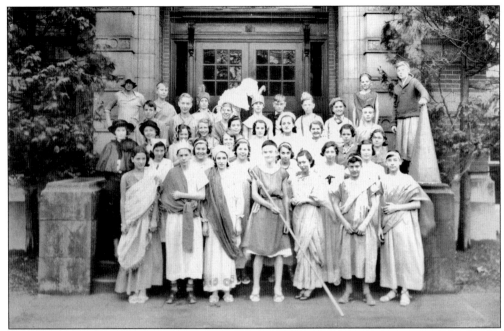

The eighth-grade class of Ravenna Elementary is pictured on January 25, 1933, costumed for their class play. Other school photographs from this time period show tableaux on stage related to Greek culture. A Greek woman, Greek youth, and discus thrower were among those highlighted. (Courtesy Carol Kocher.)

In 1930, Miss ? Dean was Ravenna Grade School's music teacher. What might she have thought of the battle between the Methodists and the park board regarding turning the Park Club House into a Community Dance Hall? The Methodists felt this would "lead our young people astray" and "bring . . . undesirable people." The board answered "it is the thought in the minds of some people that . . . causes harm, but not the dancing itself." (Courtesy Carol Kocher.)

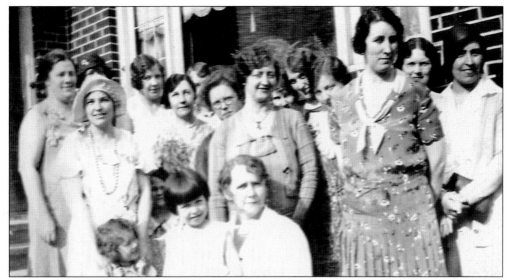

The 1931 Ravenna Grade School PTA is pictured here. Olive Cumbo's involvement with the PTA started when her oldest daughter, Florence, began school there around 1916. Her leadership in the organization continued into the 1930s, when her youngest daughter, Marion, was attending Ravenna. (Courtesy Carol Kocher.)

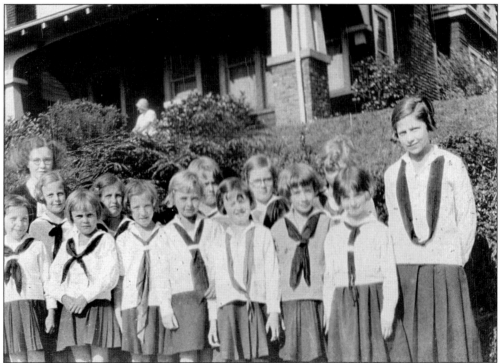

Olive also held leadership positions in the Camp Fire Girls, and in December 1938, she was awarded the Torch Bearer in Leadership for all her many contributions over the years. This was the highest honor a leader could obtain. Here Olive is shown in 1932 with Marion's Bluebird troop. Her coleader, Suzanne Alle, is also pictured. Marion loved her Camp Fire Girls experience, especially when she was elected scribe. (Courtesy Carol Kocher.)

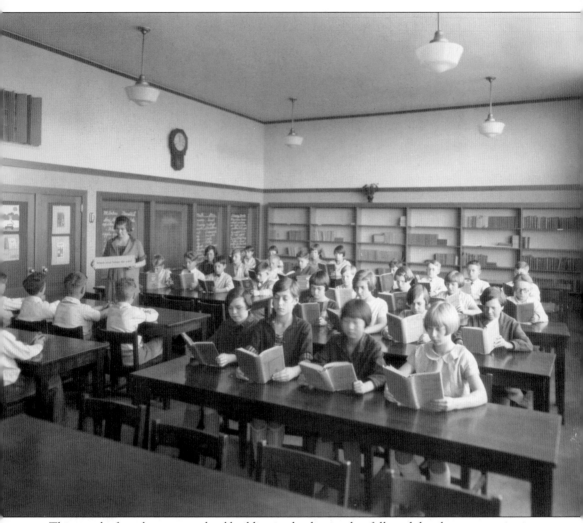

This was the first elementary school building in the district that followed the platoon organization, which included a library, gym, and music, art, and home economics rooms. This organization offered students classes focused on specific academic topics, often taught by teachers who specialized in that area. Here students are assembled in the library, and the librarian is holding a sign that states, "Which wind brings cold?" This most likely is a reference to the poem *Weather Wisdom* by Ernest Thompson Seton, which says in part:

> A circle round the moon means "storm." As many stars as are in circle, so many days before it will rain.
> Sudden heat brings thunder.
> A storm that comes against the wind is always a thunderstorm.
> The oak and the ash draw lightning. Under the birch, the cedar, and balsam you are safe.
> East wind brings rain.
> West wind brings clear, bright, cool weather.
> North wind brings cold.
> South wind brings heat. (On Atlantic coast.)

(Courtesy SPS.)

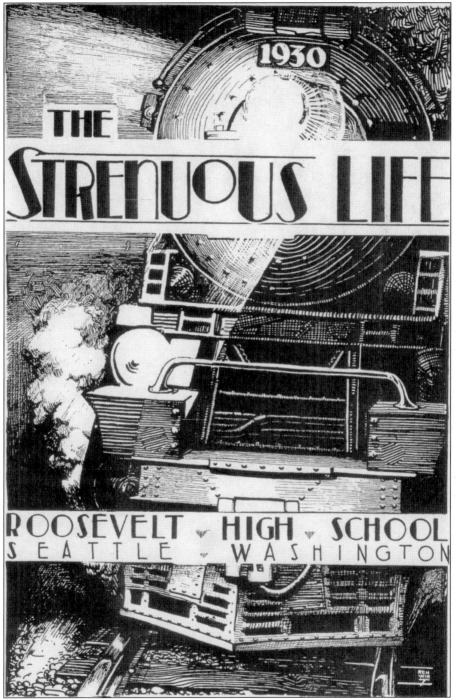

This illustration from Roosevelt High School's yearbook *Strenuous Life* is a wonderful example of art deco, an innovative design style popular in the 1920s and 1930s. The economic and social pressures that followed World War I and entry into the Machine Age brought a new desire for a clean-cut look. Its sleek, streamlined forms conveyed both elegance and sophistication. Influences included cubism, futurism, machines, and graphic design. (Courtesy SPS.)

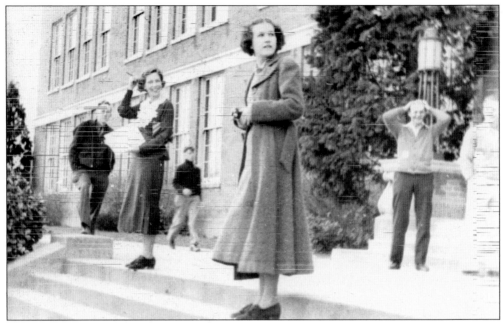

This photograph was taken by Cameron Cooper, a teacher at Roosevelt High School, and was used in the 1937 yearbook. The teens pictured on the front steps of the school from left to right are Dick Anderson, Marion Cumbo, Alice Gregor, Hilmer Mattson, and Harold Wolever. (Courtesy Carol Kocher.)

This photograph is included in the 1934 Roosevelt High School *Strenuous Life*. The yearbook's name was taken from a speech by Theodore Roosevelt: "I wish to preach, not the doctrine of ignoble ease, but the doctrine of the strenuous life . . . to preach that highest form of success which comes . . . to the man who does not shrink from danger, from hardship, or from bitter toil, and who . . . wins the splendid ultimate triumph." (Courtesy Carol Kocher.)

Another image from the 1934 *Strenuous Life* shows a photograph montage entitled "In Our Classrooms." Pictured are students working in the greenhouse, giving a speech, drawing a model in figure drawing class, learning Spanish, and boat building. (Courtesy Carol Kocher.)

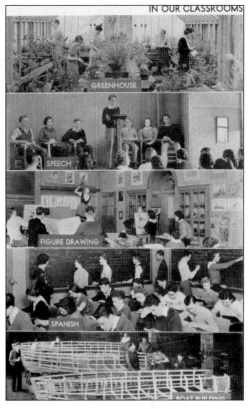

Students of Roosevelt High School mount the front steps and approach the main entrance of the school in this 1934 photograph. The caption reads, "Led by the Spirit of Liberty and Justice, members of the four races enter Roosevelt to become components of its whole." (Courtesy Carol Kocher.)

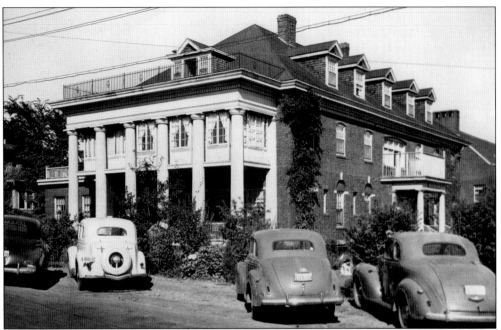

In the 1930s, the Children's Home Society focused on restructuring. Finance workers were hired to handle fund-raising, freeing field staff to concentrate solely on the needs of the children. In addition, Frances Schmidt was hired as casework supervisor. A graduate of the Boston School of Social Work, she was the first university-trained social worker hired by the society. (Courtesy CHSW.)

During the 1930s, Minnie Walker; her daughter, Vivian Walker Newsom; and sons Bryon (left) and Don visited Seattle from Colorado. Here they are posed in Ravenna Park, which had continued over the years to be a tourist attraction. (Courtesy Carol Kocher.)

George Cumbo sits quietly in his backyard contemplating his newly built pond. Elsewhere in the city, men and boys in the WPA and CCC were building trails and the art deco Cowen Park Bridge nearly 60 feet above the Ravenna Creek bed. The architecturally notable bridge is made from reinforced concrete. (Courtesy Carol Kocher.)

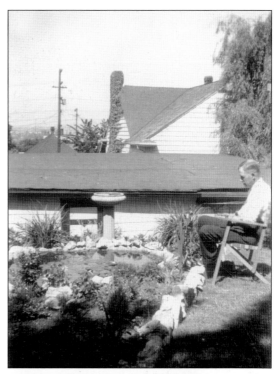

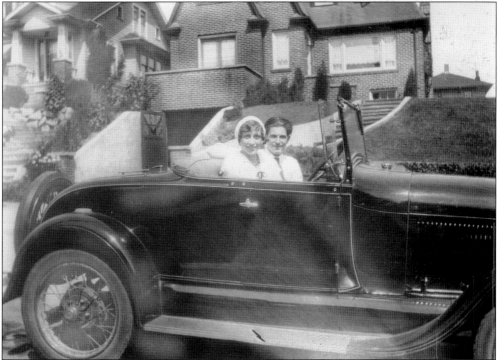

Florence Cumbo is driven by a friend in the early 1930s on her street in Ravenna. It appears that the car might be a 1931 Dodge coupe. Prices for the coupe started at $815 for the six-cylinder and $995 for the eight-cylinder. (Courtesy Carol Kocher.)

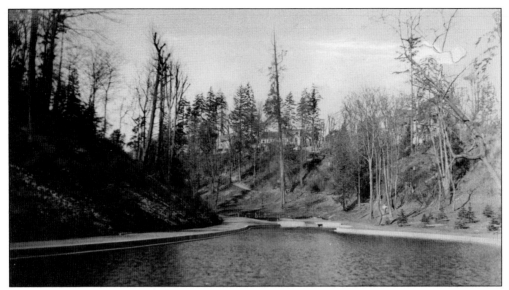

The Ravenna Pool was the result of grading during playground construction in 1931. According to notes from the Seattle Park Board, "Rather than leave this unsightly spot, it was decided to construct an ornamental pool. . . . Two lovely swans were given to the park . . . and placed in the pool. One of the swans disappeared and was never found, and for the sake of the safety of the remaining bird, it was given to the Zoo." (Courtesy SMA.)

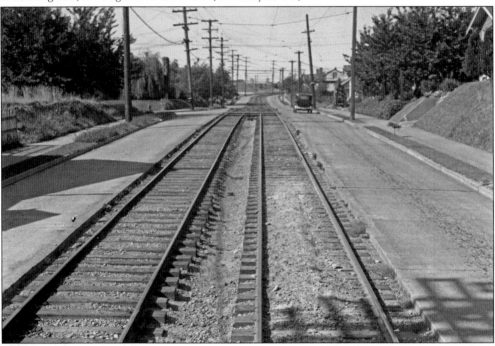

In the mid-1930s, it became safe and easy to make most trips by car. Personal car trips required much less advance planning, were conveniently door to door, and lent complete privacy. "The freedom of the open road" was a common saying. New and better streets were built rapidly as the demand increased. Pictured is Fifteenth Avenue NE before slab-paving covered the streetcar tracks. (Courtesy SMA.)

Six

THE 1940S
THE WAR, TELEVISION, AND
FLOATING BRIDGES

During the 1940s, Ravenna was a microcosm of the nation's growth in population and emerging prosperity. In 1940, Seattle's population was 368,302 and Ravenna's was 27,070. Most of the trees were gone, and while there were many houses, a number of vacant lots were still available. A popular area with returning veterans and their families was north of NE Fifty-fifth Street and east of Thirty-Fifth Avenue NE. Soon the area was filled with small, cracker box–style frame homes. In 1940, the Lake Washington Floating Bridge opened at the south end of Ravenna, connecting Seattle with the Eastside and the new suburbs to each other.

In 1941, Japan attacked Pearl Harbor and the United States entered World War II. In Seattle, cowboys, stunt men, and blacksmiths rode the coast acting as armed beach patrols for the Coast Guard. In 1942, Japanese Americans were ordered to evacuate Seattle, and more than 12,000 King County citizens of Japanese ancestry were held in relocation centers. In Seattle, moviegoers flocked to the Telenews theater at Third Avenue and Pike Street, which showed only war newsreels.

In 1945, the United States dropped atomic bombs on Japan, ending World War II. In Seattle, an earthquake shook the Puget Sound. In Ravenna, what would become the Northeast Branch of Seattle Public Library got its start as the Ravenna/View Ridge deposit station. Seattle author Betty MacDonald wrote *The Egg and I*, which in 1946 was adapted into the *Ma and Pa Kettle* series. In 1948, Roosevelt High School graduate Howard Duff starred in the *Naked City* and was the voice of radio's Sam Spade. Also in 1948, thousands of people crowded into Frederick and Nelson's department store to see the first local television broadcast by KRSC, Seattle's only television station.

In 1948, Ravenna battled the city engineer over efforts to divert Ravenna Creek into sewers in one of the first indications of the community activism that would become a hallmark of the neighborhood. In 1949, the Seattle-Tacoma Airport opened, and an earthquake measuring 7.1 on the Richter scale killed seven people. By the end of the decade, the population of Ravenna would grow to 39,429.

The June 1943 issue of the Children's Home Society *Home Finder* stated, "Of 196 children accepted by us last year for placement in normal, happy homes, a great many of them came directly or indirectly because of war problems. Sometimes it was called 'housing', sometimes 'broken home', but many times it was just called 'war.' " (Courtesy CHSW.)

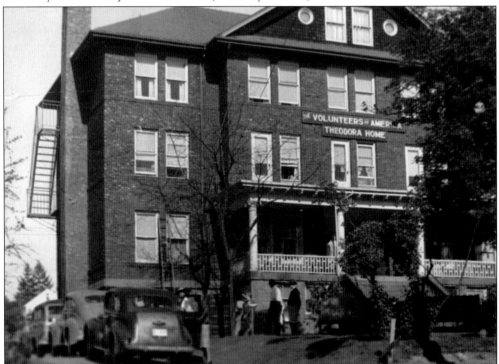

Although the Volunteers of America provided a wide variety of services in Washington and felt that thousands benefited from the multi-service approach, by the end of the 1940s, the Theodora was the only existing program. (Courtesy the Theodora.)

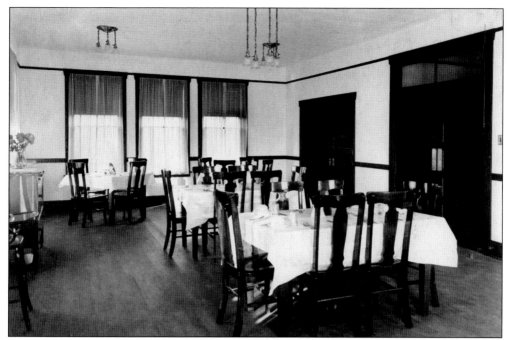

For two more decades beyond the 1940s, until 1965, the Theodora continued to provide housing for women and children. Here the dining room is shown with tablecloths on the tables and beautiful flowers on the sideboard. (Courtesy the Theodora.)

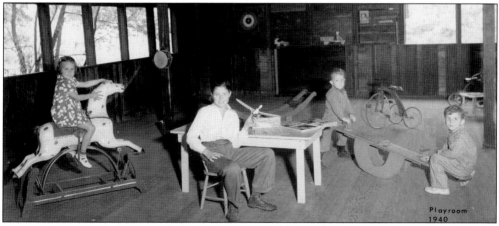

Pictured is the wood-paneled room that was the Theodora's playroom in 1940. A young girl rides a hobbyhorse, and two boys are on a teeter-totter. Elsewhere in the room are tricycles, a drum, wooden pull toys, and a dartboard. The boy in the foreground is holding a model airplane built from a kit. (Courtesy the Theodora.)

In 1940, the Ravenna Methodist Church had a membership of 224, and the Sunday school boasted enrollment of 303. The Ladies Aid was able to contribute $406 to the annual conference. In 1938, the Methodist Protestant church deeded the property the church stood on to Ravenna. The parsonage and its contents were valued at $3,000 and the edifice at $40,000, figures that were quite substantial at 1940 prices. (Courtesy RUMC.)

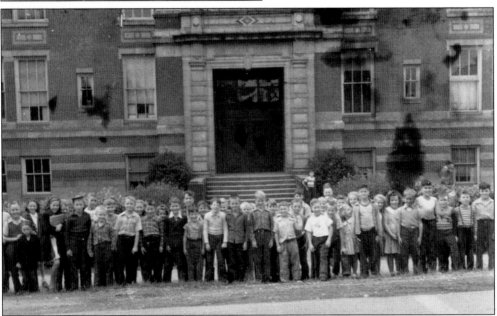

In 1946, Ravenna's students gather for an informal photograph. In four years, the site would expand to four and a half acres and lose its seventh and eighth grades to the new junior high school. Alumni from this time reminisce about the Halloween costume parade that would wind through the halls to the auditorium stage and stopping for a Green River float at the drugstore soda fountain at NE Fifty-fifth Street and Thirty-fifth Avenue NE. (Courtesy SPS.)

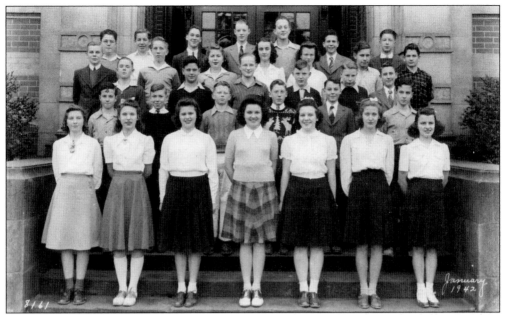

Seattle grew quickly when the United States entered World War II. North of NE Sixty-fifth Street filled with houses as workers flocked to Seattle to work for Boeing and the Naval Station. Many young, professional parents chose to live in this area because of the excellent reputation of the schools. In doing so, Boeing workers put up with an hour commute each way, as Interstate 5 did not yet exist here. (Courtesy SPS.)

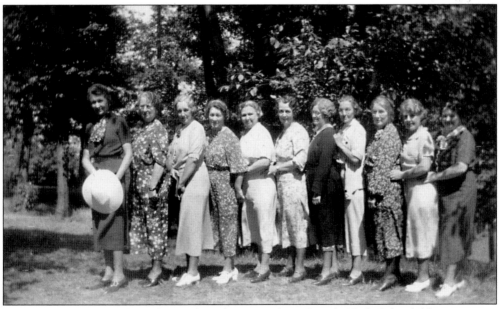

For many years, the ladies who graduated in 1903 from Seattle High School (the name was changed to Broadway High School in 1909) would get together in the summer for a gathering. Olive Mueller Cumbo is in the center of the ladies in this photograph taken at Ravenna Park in 1940. (Courtesy Carol Kocher.)

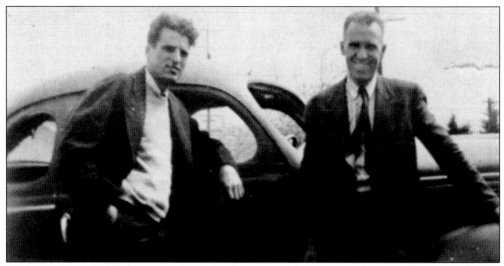

In the summer of 1941, Harry Leighton and Paul Waterman (pictured) opened a shop on Thirty-fourth Avenue NE and NE Fifty-fifth Street called Ravenna Auto Rebuild. From there, they rebuilt cars and bought and sold them on the side. (Courtesy Ravenna Volvo.)

The auto rebuild business that Harry Leighton and Paul Waterman started in 1941 grew rapidly, and in 1946, they built a building across the street from their showroom. In 1948, they decided to look into selling new cars and settled on five cars in the Austin line. (Courtesy Ravenna Volvo.)

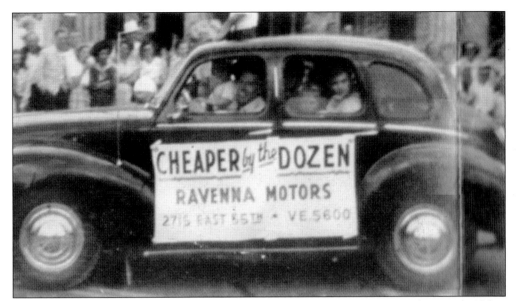

When the Ravenna Motors founders decided to start selling new cars, Harry Leighton said, "If they don't sell, we've still got the body shop." The cars sold so well that the two men soon expanded by adding MG and Austin Healy cars. (Courtesy Ravenna Volvo.)

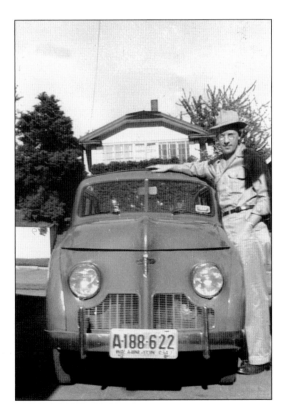

This photograph shows the author's father, Ted Wendell, standing next to his pride and joy, a 1947 Crosley convertible parked in his driveway on Twenty-ninth Avenue NE. During World War II, the Crosley was popular because of its good mileage (50 miles per gallon) during gasoline rationing. Ted and his wife, Virginia, drove from Chicago to Seattle in 1948 in the Crosley for Ted's new job at Fredrick and Nelson. (Courtesy Wendell family.)

John Doncaster, one year old, stands proudly on his mother's lap on the sidewalk in front of his grandparent's house on Seventeenth Avenue NE in 1940. Although Dr. Benjamin Spock's influential *Baby and Child Care* would not be published until 1946, Florence had her family at hand who might well have shared his most famous advice: "Trust yourself. You know more than you think you do." (Courtesy Carol Kocher.)

In a pose that would not have been out of place in *It's a Wonderful Life*, young John Doncaster sits on his father's lap while he reads *'Twas the Night Before Christmas*. The tinsel-bedecked tree in the background could not have been bought at Seattle-favorite Chubby and Tubby, as it wouldn't open for another seven years. (Courtesy Carol Kocher.)

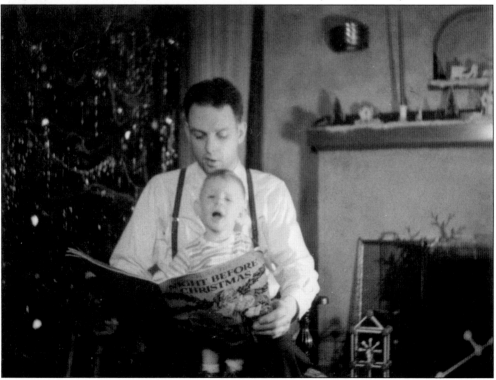

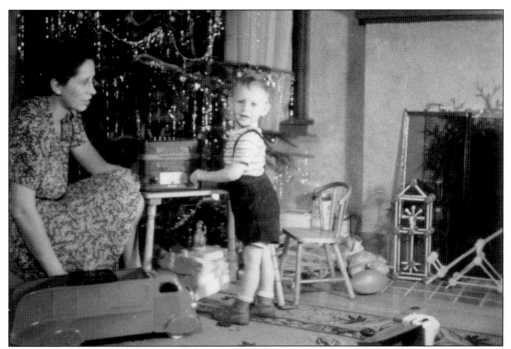

This photograph from Christmas 1940 gives a sense of some of the popular presents of the time. Toddler John has received a football, Tinker Toys, and a large push panel truck. He is turning the knobs on a vacuum-tube portable radio. (Courtesy Carol Kocher.)

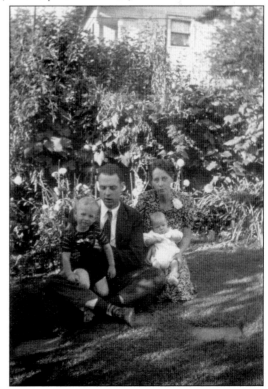

Here the Doncaster family (Ensley, Florence, John, and baby Bill) sits for an informal family portrait on Easter morning. Most likely, they had already attended services at University Lutheran Church. Young married couples like the Doncasters were often involved in church groups that had names such as "Faith, Fun, and Fellowship." (Courtesy Carol Kocher.)

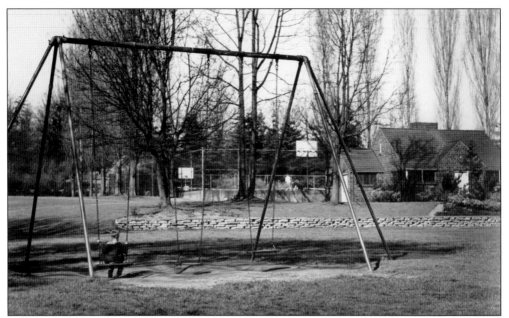

This photograph taken March 31, 1947, of Ravenna Park shows a more-developed area near the Ravenna Pool. Tennis courts are visible as is the field house. In the foreground, a child rests on the swing set that remains in that location to this day. Currently a group called Friends of Ravenna Playground has raised $383,780 for new play equipment and plans an opening ceremony for spring 2007. (Courtesy SMA.)

The Northeast Branch of Seattle Public Library, 6801 Thirty-fifth Avenue NE, began as the Ravenna/View Ridge deposit station (a holding room for books). The library told the Ravenna Library Committee that they would staff a location if one could be found. Committee members went door to door to raise funds, then cleaned and built shelving for a space at 6259 Thirty-third Avenue NE, which opened in December 1945. (Courtesy Ann Wendell.)

Seven

THE 1950S
SHOPPING MALLS, CANDY CANE LANE, AND A REALLY BIG HOLE

In 1950, the United States entered the Korean War and President Truman survived an assassination attempt. In Seattle, the population was 467,591, the first Seafair celebration was held, and Northgate Mall, one of the nation's first shopping malls, opened. In 1952, Seattle celebrated its centennial. The Korean War ended in 1953, and locally voters agreed to annexations that extended Seattle to N 145th Street. By 1954, Dick's Drive-In had opened in Wallingford, and the Boeing 707 took its first flight.

The growth in the University of Washington after 1950 meant that many faculty, staff, and students made their homes in Ravenna. In 1945, there were 7,000 students. That number tripled over the next 15 years. By the 1950s, much of Ravenna south of what is now the Burke-Gilman Trail was landfill, filling the drained Union Bay Marsh and much of Union Bay. In 1956, the University Village Shopping center was built on the southernmost reclaimed land in Ravenna.

One of Ravenna's best-known attractions got its start in 1951. Japanese immigrant Tatsuya "Larry" Kawabata became determined to win a citywide contest to see who could "best capture the spirit of Christmas through the decoration of their house." This was the beginning of Candy Cane Lane, where Park Road residents continue to create elaborate holiday displays bringing bumper-to-bumper traffic.

In 1957, some 15,000 screaming teens paid up to $3.50 for a ticket to see Elvis Presley perform at Sick's Stadium. In Ravenna, excitement of another nature happened a month later when a break occurred in the 50-year-old Ravenna Trunk Sewer. Within an hour, the cave-in of the brick sewer tunnel caused a sinkhole to appear in Ravenna Boulevard. As the sinkhole grew wider, 10 families were evacuated out their back doors in the early morning hours. It eventually grew to 175 feet wide, 200 feet long, and 50 feet deep. The sewer was the largest in the city, and service was out for a 13-square-mile area in which 43,000 people lived. This sewer break was the most costly experienced by any city in the country up to that point.

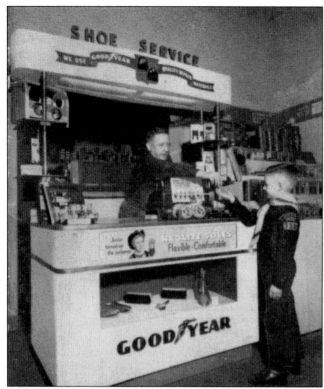

Hugh McManus started McManus Shoe Repair Shop at 5503 Thirty-fifth Avenue NE in 1946. Here in a photograph illustrating a story in the July 1952 issue of *Master Shoe Builder*, he demonstrates service to a customer with his son, John, shown proudly wearing his Boy Scout uniform. John has continued in his father's footsteps and is a certified pedorthist at the same location. (Courtesy McManus Shoe and Footcare Center.)

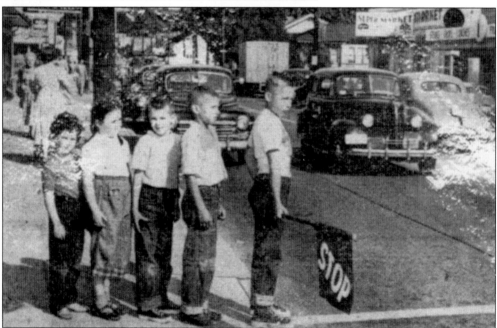

In a *University Herald* newspaper story from the early 1950s, school safety patrol Richard Rucker of 6206 Twentieth Avenue NE demonstrates the proper way to cross the street at the corner of E Sixty-fifth Street. Behind him from left to right are Susan and Gloria Brown, Stevie Lockitch, and Red Rucker, all students at Ravenna Elementary School. (Courtesy SPS.)

It was only in 1950 that mass-produced candy canes became an inexpensive Christmas staple. Locally, Tatsuya "Larry" Kawabata, the founder of Candy Cane Lane, was one of the first to use them as decoration. By 1955, the neighborhood display earned a mention in the *Times* and a subsequent increase in the number of cars making the trip to the newly named "Candy Cane Lane." (Courtesy Ann Wendell.)

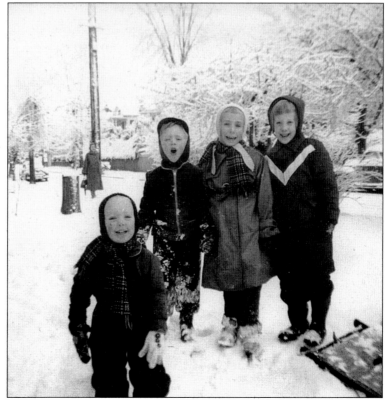

From left to right are Pat, Mike, and Christine Rowe joining Robin Wendell for Snow Day fun on Twenty-ninth Avenue NE in 1953. The two families lived four houses away from each other and were frequent playmates, although the Rowe children went to Assumption, the local parochial school, while the Wendell girls went to Bryant, a public school. (Courtesy Wendell family.)

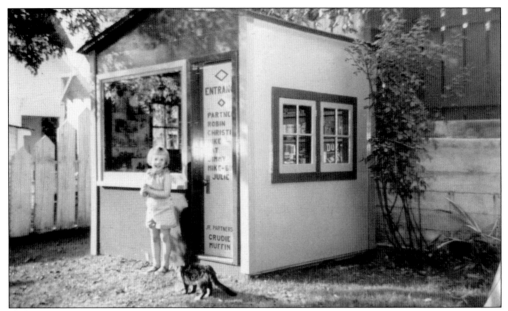

In 1952, Robin Wendell stood outside the play store in her backyard built by her father. The shelves held empty cans and boxes and a cash register. The yard included swings, jungle gym, slide, and a stand-up, roofed sandbox. The door listed Robin's friends and pets, including the cat, Muffin. All subsequent pets owned by the Wendell family were also named Muffin to avoid repainting the door. (Courtesy Wendell family.)

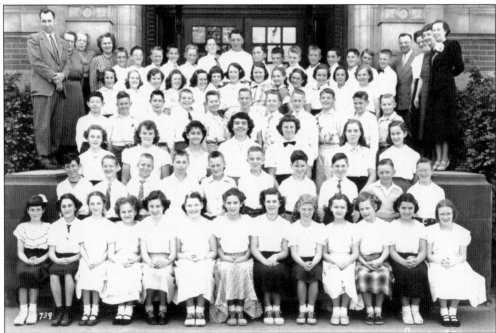

Several of the girls here are wearing saddle shoes, which were considered to be a rather sporty shoe and were worn like loafers in the years before sneakers were fashionable. Although the boys' shoes are not visible, we can assume many boys also wore them. They were not worn on dressy occasions but might be worn with sport jackets by older boys on informal occasions. (Courtesy SPS.)

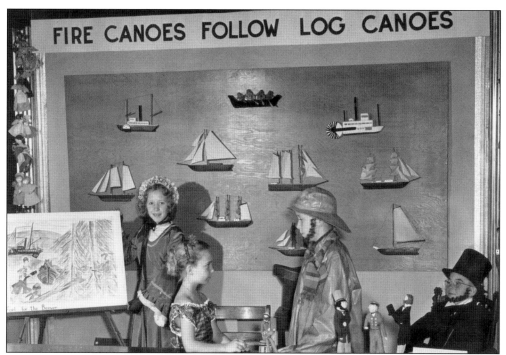

FIRE CANOES FOLLOW LOG CANOES

Ravenna students are shown here in costume (including Abe Lincoln) presenting an exhibit at Edison Technical School around the 1950s. Their exhibit showed the progress of boat construction with the term "fire canoes" being used to denote steamboats. Each ship mounted on the background panel was carved out of wood. A father of one of the students, whose hobby was model shipbuilding, had assisted them. (Courtesy SPS.)

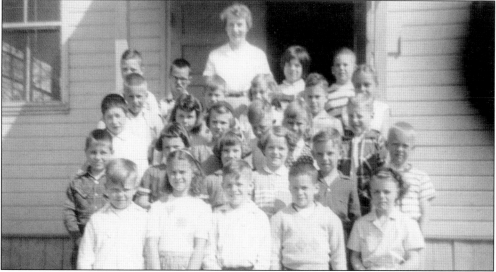

The second-grade class at Bryant poses in front of their portable in May 1956. Standing on the portable porch in back of them is their teacher, Mrs. ? Leitz. During the 1950s, Bryant gained a reputation for its fund-raising Carnival. The *Seattle Times* noted on January 20, 1952, "One of the most successful of these annual events is held at Bryant School, where more than $1,000 was taken in during a single evening." (Courtesy Wendell family.)

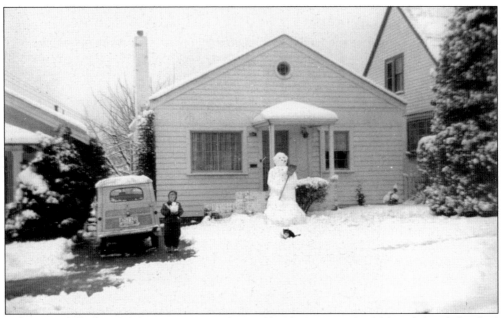

Robin Wendell shows off her snowman in front of her house in 1953. Although her father had traded in the Crosley convertible for the more family-oriented station wagon, the car was still tiny. One advantage was that it was narrow enough at 48 inches to go through a standard commercial store door. This way, the same dealers who already handled Crosley radios and refrigerators could sell it. (Courtesy Wendell family.)

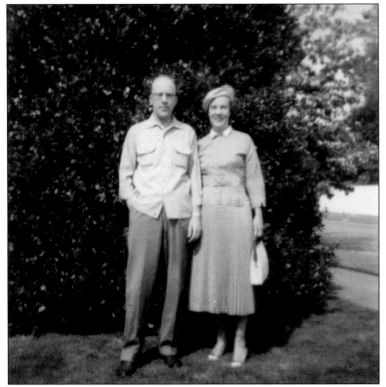

Ted and Virginia Wendell are pictured in 1956 when the stuffy formality of the 1940s was left behind. The fabric of Ted's shirt was "wash and wear," with no ironing required. Virginia wore a head-hugging Baker Boy beret. Bags in the 1950s were held by the hand or over the arm, like Grace Kelly, who used her Hermes bag to hide her pregnancy. (Courtesy Wendell family.)

The author, a little over one year old in 1959, stands beside the large holly tree in her front yard. Every Christmas season, the family would brave the prickly leaves of the tree to fill shopping bags with holly boughs for the neighbors. In the back of the tree was a small, secret passage, and the hollow interior became a childhood fort. (Courtesy Wendell family.)

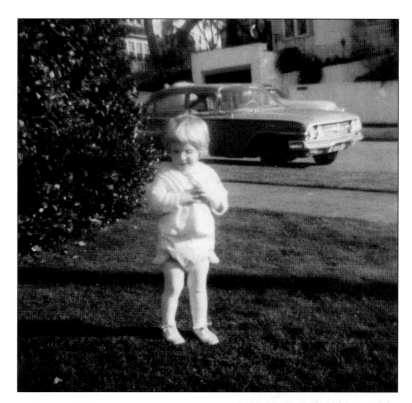

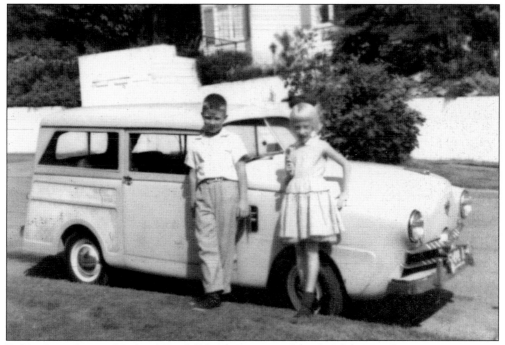

Bobby Roombus and Robin Wendell lounge against the side of the Crosley station wagon in 1956. Notable Crosley owners included Humphrey Bogart, Paulette Goddard, Art Linkletter, and President Eisenhower. (Courtesy Wendell family.)

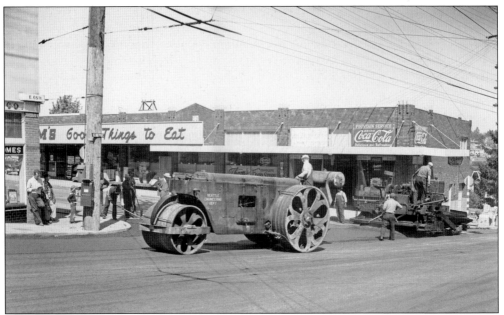

Diesel Roller No. 736 with the city's engineering department paved NE Sixty-fifth Street at Twentieth Avenue NE on May 24, 1950. In the background can be seen Thom's Grocery, which proclaimed "Good Things to Eat." There was also a soda fountain available serving Coca-Cola and Stokes Ice Cream. This would be the future site of first the Pacific Consumers Cooperative and currently Third Place Books. (Courtesy SMA.)

In 1953, the city removed an existing peat swamp at 7700 Twenty-fifth Avenue NE to create Dahl Playfield. In 1947, the 80 parents of Cub Pack 165 began the first efforts to acquire the site, originally known as the "Ravenna Swamp." In 1955, the park board renamed it to honor Waldo J. "Red" Dahl, who served nine terms as president of the board. (Courtesy SMA.)

Here seagulls circle over the University Sanitary Fill (know colloquially as the "City Dump" and best known to Seattle children as the home of J. P. Patches, beloved local entertainer) in 1954. After years of use for waste disposal, these sanitary fills were often reclaimed for buildings, parks, and parking lots, and two years later, the University Village Shopping Center was built across NE Forty-fifth Street. (Courtesy SMA.)

In this 1951 photograph, we see Twentieth Avenue NE before the street was widened. We also see an electric bus, first introduced in Salt Lake City, Utah, and later in Portland, Oregon, in 1928. They gained popularity as they didn't require expensive rails and, unlike streetcars, could pull up to the curb so as not to load and unload passengers in the middle of the street. (Courtesy SMA.)

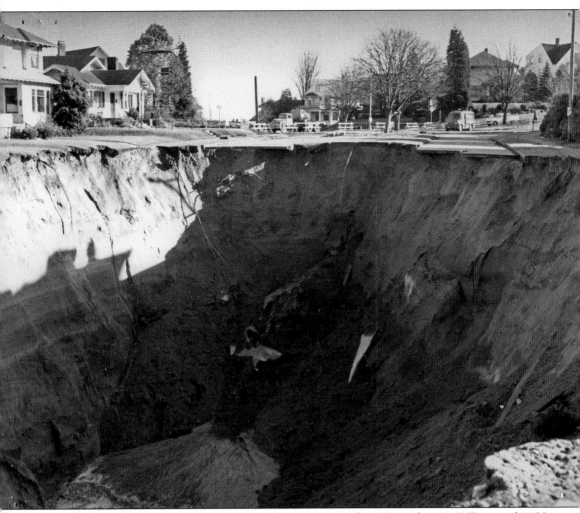

The break in the 50-year-old Ravenna Trunk Sewer occurred on November 11, 1957, around 11:30 p.m. By midnight, 8,000 cubic yards of debris had moved a quarter mile down the tunnel. At this point, City Engineer Roy Morse sprang into action. Working around the clock, employees built a bypass sewer through Ravenna Park. A cofferdam consisting of 5,400 feet of welded steel pipes and pumps was installed. Service was restored by November 22, 1957. Local historian Paul Dorpat later wrote of being taken as a tourist to the edge of the hole, which became a neighborhood attraction. Repairing the original sewer, which had been built in quicksand, was another story and took months to complete. The huge hole caused by the cave-in eventually swallowed 16,000 cubic yards of fill. This process involved barges from Steilacoom, trucks to the site, and then a conveyer belt from Seventeenth Avenue NE to the center of the hole. This took 10 days. The entire cost of repairing the cave-in was $2 million and wasn't complete for two years. (Courtesy SMA.)

Eight

THE 1960s
THE BEATLES, BOMB SHELTERS, AND HIPPIES IN THE PARK

In 1960, Seattle's population was 557,087, John F. Kennedy defeated Richard Nixon, and the UW football team won its first Rose Bowl. The next year, Bill Kirschner invented the fiberglass snow ski and would go on to form the company K2. This was also the year the State of Washington built a fallout shelter at NE Sixty-fifth Street and Ravenna Boulevard as part of the Interstate 5 project in response to the Federal Civil Defence Act of 1950. It was designed to house 200 people in the event of a nuclear attack. The shelters were supposed to be integrated into the daily life of the community, and so the Ravenna shelter became a driver's licensing facility.

In 1962, John Glenn orbited the earth and the World's Fair opened in Seattle. That year, in September, Western Washington's first tornado hit. The funnel touched down with 100-mile-per-hour winds at the View Ridge Playfield. At least one boy was lifted off the ground. It knocked down three fences and damaged eight homes before reaching the house at 7308 Forty-fourth Avenue NE where six-year-old Bill Gates and his family lived. In August 1963, the Evergreen Point Floating Bridge opened, and in November, President Kennedy was assassinated.

The August 21, 1964, appearance of the Beatles set off pandemonium in the streets, and soon Seattle schools banned long hair on boys. In 1965, an earthquake hit, measuring 6.5 on the Richter scale, killing eight. At the end of 1966, Boeing started to build the Super Sonic Transport (SST), and Seattle's population peaked at 574,000. By 1967, Interstate 5 was completed, Jimi Hendrix made his hometown debut, and the underground newspaper the *Helix* began publication and endorsed "Be-ins" at Ravenna Park. As the decade drew to a close, the congregation Beth Shalom was established in Ravenna, the 50-story Seafirst Building was completed, and man walked on the moon.

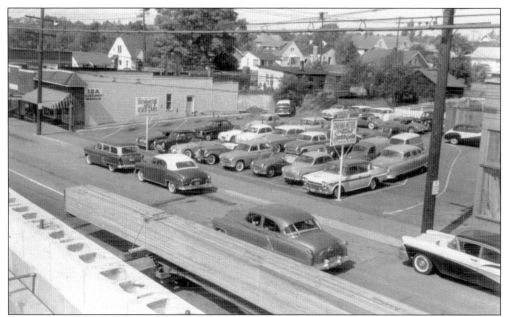

This photograph from the mid-1960s looks north from NE Fifty-fifth Street and Twenty-seventh Avenue NE. In 1962, Ravenna Motors gave selling Volvos a try with much success. By 1968, they took over the IGA store. IGA was one of the first to utilize a design that ensured customers passed all the other merchandise in the store before reaching the dairy and bread sections. (Courtesy Ravenna Volvo.)

Earl's TV Repair served the Ravenna neighborhood for many years. In 1996, ninety-six percent of NBC's prime-time shows were in color, and CBS and ABC would soon follow suit. Discount houses were offering 19-inch color sets for less than $300. Videotape recorders sales had reached $40 million in 1964. The gumball machine shown in the narrow space between the buildings was most likely from the adjacent candy store. (Courtesy Queen Mary.)

The corner of NE Sixty-fifth Street and Twenty-seventh Avenue NE is shown around the 1960s in a snapshot found in a shoebox of old photographs at local shop M. R. Johnson's Antiques. The people pictured are dressed in vintage clothing and are perhaps en route to a vintage car show, as they stand next to what looks to be a Ford Model A. (Courtesy Ann Wendell.)

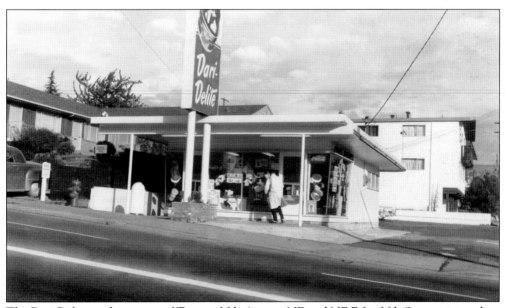

The Dari-Delite at the corner of Twenty-fifth Avenue NE and NE Fifty-fifth Street, pictured on November 3, 1961, was the hangout for local children and teens who gobbled up their root beer floats, dream boat specials, and 15¢ chocolate dipped cones. Here a businessman stops for a treat, perhaps on his way home from the No. 74 bus stop. (Courtesy Kidd Valley.)

The 1963 Roosevelt High School football team is shown here in the new gymnasium, which opened in 1960 west of the main building. The 1960s brought additional remodeling, including a new library, home economics labs, and music rooms. An annex was built in 1965, replacing the portables, and contained classrooms for art and industrial arts as well as a cafeteria. (Courtesy SPS.)

The Cheer Squad of Roosevelt High School poses with their mascot, the Teddy Bear. The boys' sweaters show an image of Roosevelt wearing his Rough Rider uniform, complete with a Montana Peak slouch hat and gaiters. The sweaters of the girls are adorned with a musical note and a teddy bear. The hairstyles of both the boys and girls indicate the time period as being during the 1960s. (Courtesy SPS.)

The sports teams at Roosevelt High School were known as the Rough Riders in reference to the all-volunteer cavalry led by Theodore Roosevelt during the 1898 Spanish-American War. In this photograph, taken in the early 1960s, the uniforms of the boy's basketball team refer to them as the "Teds." The Roosevelt basketball team would go on to win the state basketball championship in 1972–1973. (Courtesy SPS.)

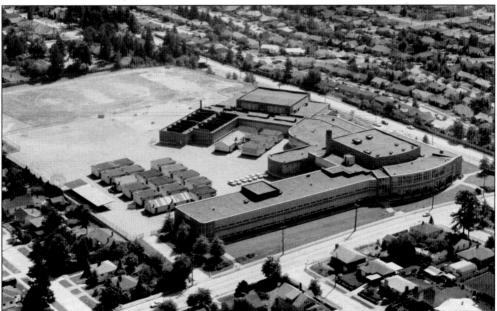

Nathan Eckstein Junior High, shown here in 1965, was named for a civic leader from one of Seattle's first Jewish families. Until the 1930s, this area was forest and a few scattered farms. As Seattle's population grew, this area became popular for new homes, parks, and schools. Eckstein's location at Seventy-fifth Street and Thirty-second Avenue NE had most recently been a horse pasture prior to its opening in 1950. (Courtesy SPS.)

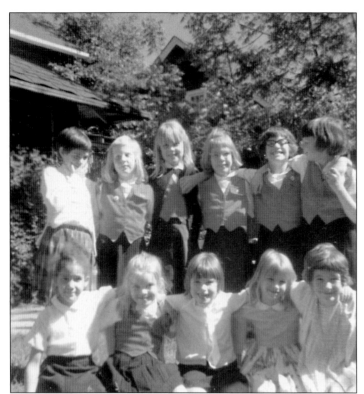

The author's Bluebird troop is shown here in 1966 outside of leader Mrs. ? Hawkins's house near Bryant School. Bluebirds are the younger sisters of Camp Fire Girls, and their watchword is "Wahelo," made up of the first two letters each of work, health, and love. They eventually "fly up" to become Camp Fire Girls in a special ceremony. The author is standing second from the left. (Courtesy Wendell family.)

At this 1966 birthday party, the author turned seven. From left to right are (first row) unidentified, Elizabeth Hawkins, Patty Brown, and Cezanne Thomas; (second row) unidentified, Margaret Taylor, unidentified, Ann Wendell, Lorraine Rowe, and two unidentified. Twister, the popular party game, made its debut that year and was sure to have been a hit with these girls. It sold more than 3 million games within a year of its release and has sold more than 22 million since then. (Courtesy Wendell family.)

Claire Rowe is pictured here with two older girls—her sister, Christine (right), and Robin Wendell—in 1964. Although many think of the entire 1960s as the era of the miniskirt, Mary Quant did not produce the first one until 1966. When the fashion did hit, Seattle girls who wore them to school had to pass "the fingertip test" for length. (Courtesy Wendell family.)

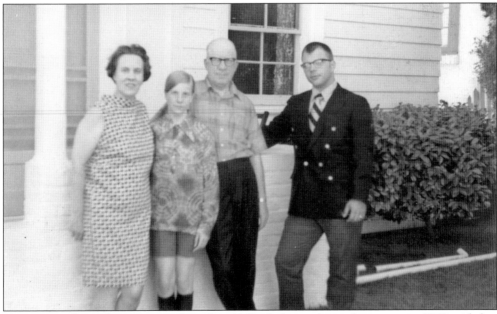

Showing perhaps the worst trends in late-1960s fashion, the author poses in 1968 with her parents, Virginia and Ted Wendell, and cousin Bobbie Rhombus. If Virginia's sheath had been more colorful, it might have passed for a "Lilly," named for Lilly Pulitzer, a Florida socialite who designed them for carefree summer wear. The author's mass-produced tie-dyed shirt was supposed to express the era's "do your own thing" attitude. (Courtesy Wendell family.)

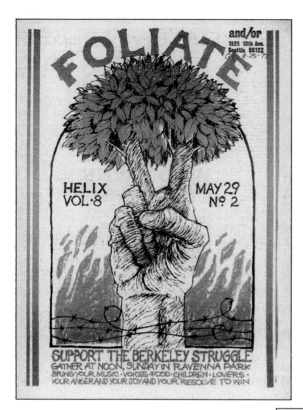

Helix, Seattle's first underground newspaper, edited by Paul Dorpat, debuted on March 23, 1967. This cover from 1969 showcases an upcoming gathering in Ravenna Park. Soon after this, the park board received letters complaining of "drum-beating, recorder-playing, stick-tapping hippies . . . the crowds roamed, the traffic snarled, the beer and wine flowed and the pot was inhaled." (Courtesy Wendell family.)

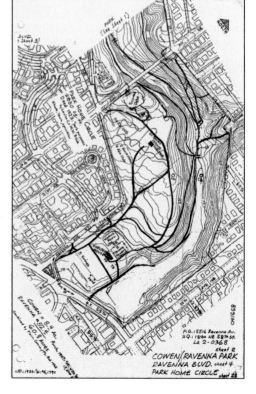

This map is the legacy of Donald N. Sherwood (1916–1981), who worked as an engineer for Seattle Parks for 22 years from 1955 to 1977. In the course of his work, which included designing buildings and producing brochures, Sherwood began compiling sketch maps of the parks, often annotating them in great detail with the history of the area. (Courtesy SMA.)

Nine

THE 1970S

PROTESTS, PUBLIC TRAILS, AND THE PCC

In 1970, war protestors took to the streets in major cities including Seattle. Seattle's population was 530,831, and Medic One had just begun pioneering on-site cardiac care. Around this time, the city suggested that Ravenna's Twentieth Avenue should become a north-south thoroughfare. In order for this to be feasible, city engineers wanted to rebuild and widen the bridge over the park. Historically, and to this day, what sets off Ravenna residents is traffic. The neighborhood had already been instrumental in killing the plan for the proposed R. H. Thompson freeway, feeling it would have destroyed several Seattle neighborhoods. When the neighborhood objected to this latest idea, the city threatened to shut the bridge down altogether to car traffic and turn the street into a dead end. Ravenna residents embraced this idea, and the bridge now is one of the city's most scenic footbridges.

Ravenna's Puget Consumers Cooperative, at NE Sixty-fifth Street and Twentieth Avenue NE, was affectionately known as the "mother ship" when it opened in the 1970s, and Starbucks opened its first café in April 1971. That same year, Congress killed the SST, forcing Boeing to lay off another 7,000 workers. Seattle's unemployment rate had already hit 10 percent because of what was called the "Boeing recession." The next few years brought Watergate, Nixon's resignation, and the ruling that treaty Native American tribes were entitled to half of the local commercial salmon fishing. The Vietnam War ended with the fall of Saigon, and Jimmy Carter was elected president. Locally, the Kingdome opened with a Billy Graham Crusade.

By the end of the 1970s, the Shah would flee Tehran and gasoline shortages would hit across the nation. In Washington, the Hood Canal Floating Bridge sank during a storm, and the Seattle Supersonics won the NBA championship. In Ravenna, the first 12.1 miles of the Burke-Gilman Trail was opened as a public trail running from Seattle's Gas Works Park to Kenmore. The trail's origins can be traced to the founding of the Seattle, Lake Shore, and Eastern Railroad in 1885 by Thomas Burke and Daniel Gilman.

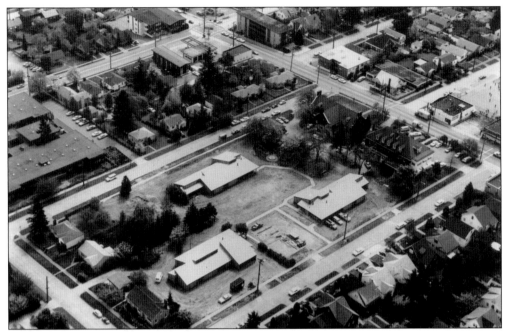

This c. 1972 aerial view of the Children's Home Society of Washington (whose name was changed in 1959) clearly shows the developed residential area around NE Sixty-fifth Street and Thirty-third Avenue NE. By this time, the society began to focus more of its energy and resources on counseling families and providing services to single parents. (Courtesy CHSW.)

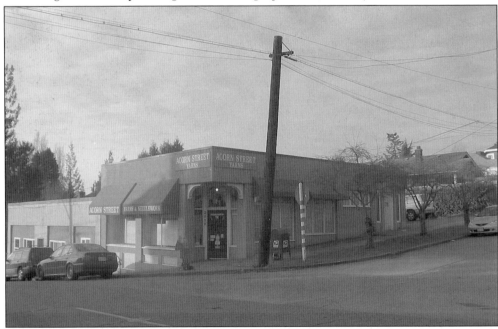

Acorn Street Shop was established in 1979 and got its start as a New England country store in nearby University Village Shopping Center. Soon the needlework department took over, and Acorn Street became a full-fledged needlework shop. In 1992, the business moved to its present location at the corner of Twenty-ninth Avenue NE and NE Fifty-fifth Street. (Courtesy Ann Wendell.)

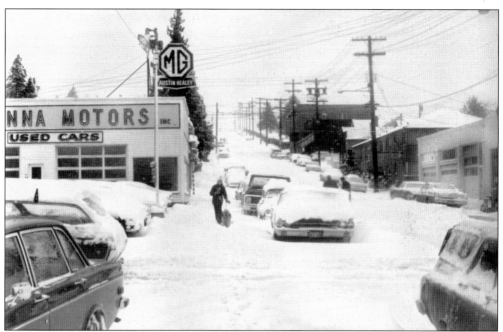

The winter of 1971–1972 could probably qualify as the longest winter ever in Seattle history. Not only does it hold the record for earliest snowfall, on October 27, but it also set the record for the latest snowfall, when 1.2 inches fell on April 17. This photograph, looking up the hill on NE Fifty-fifth Street, was taken in March 1972. (Courtesy Ravenna Volvo.)

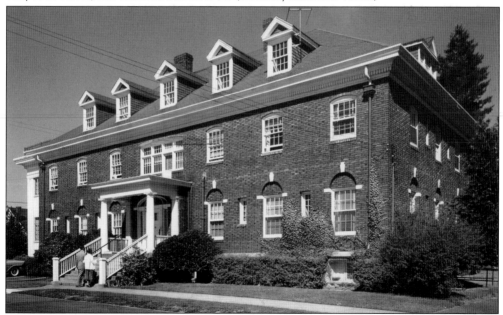

In the 1970s, single parents, once subject to much social disapproval, began to be more widely accepted. The Aid to Families with Dependent Children program began, and mothers were no longer forced to give up their children because of poverty. The society was soon to demolish Brown Hall to make room for small cottages to be used in their residential treatment center for boys. (Courtesy CHSW.)

During the 1970s, Roosevelt High School hosted an innovative program within its special education program for the deaf and hard of hearing. For class credit, hearing students, including the author, learned American Sign Language and acted as interpreters for the deaf and hard of hearing in classes they shared. (Courtesy SPS.)

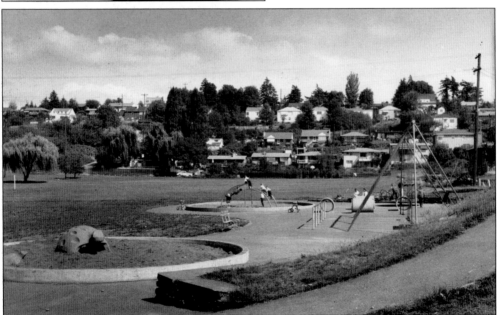

Dahl Playfield is a 15-acre park located at 7700 Twenty-fifth Avenue NE that was established in the 1950s. Here shown in 1970, the park currently includes four baseball/softball fields, three soccer fields, a playground, a wading pool, restrooms, a smaller-than-half-size basketball court, a non-continuous walking trail around the perimeter of the park, and much appreciated passive, green open space. (Courtesy SMA.)

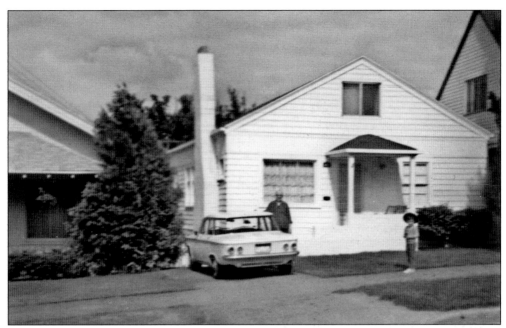

In 1970, Ted Wendell stood next to his Chevrolet Corvair, which was produced from 1960 to 1969. The Corvair was a rear-engine vehicle in the style of the Volkswagen Beetle, which was unusual for American cars at the time. It was discontinued due to plummeting sales in part because of safety issues raised by Ralph Nader's 1965 book *Unsafe at Any Speed*. (Courtesy Wendell family.)

The author and Kevin Smith pose on their way to the 1975 Roosevelt High School prom. No doubt they danced to some of the top hits of the year, including *Love Will Keep Us Together* by the Captain and Tennille, *Kung Fu Fighting* by Carl Douglas, and *The Hustle* by Van McCoy and the Soul City Symphony. (Courtesy Wendell family.)

In 1961, fifteen families incorporated their food-buying club as Puget Consumers Cooperative (PCC). By 1969, there were 650 households. Those focused on natural foods established a storefront at 2261 NE Sixty-fifth Street, and sales that year topped $66,000. In 1976, the store moved to NE Sixty-Fifth Street and Twentieth Avenue NE. An ant line of people with boxes in their arms or on hand trucks carried things around the corner. (Courtesy PCC.)

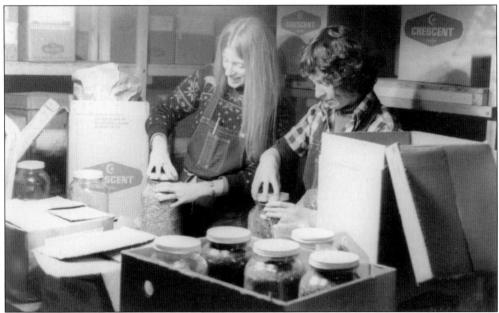

Ceci Cleveland (left) and Jody Aliesan, both staff members at PCC Ravenna for many years, fill jars with bulk spices for sale in the new store. The boxes seen are from Crescent Manufacturing Company, begun in Seattle in 1883 as a small supplier of vanilla extract. In 1905, Crescent made it big when a company chemist and salesman concocted an imitation maple flavoring dubbed "Mapleine." (Courtesy PCC.)

A Pacific Consumers Cooperative member stands next to the "Egg Room," which was located in back of the main building on Twentieth Avenue NE. As with others who had tried to keep chickens in the neighborhood, the establishment of this coop did not endear the co-op to its new neighbors. (Courtesy PCC.)

This photograph of the PCC shows no fewer than three Volkswagen buses, the ubiquitous hippie car. During the 1970s, the bus became a major counterculture symbol. It could carry a number of people plus camping gear, and as a statement, its boxy, utilitarian shape made it everything other American cars were not. Some (especially antiwar activists) would replace the VW logo with a painted peace symbol up front. (Courtesy PCC.)

Kidd Valley was inspired by trips founder John Morris took to Camp Kid, which was located near a general store that served freshly-made burgers and milkshakes. Morris opened Seattle's first Kidd Valley at 5502 Twenty-fifth Avenue NE in 1975 at the site of the old Dari-Delite. Morris sold to Ivar's in 1989, and the original sign of the "burger babe" resides at the Museum of History and Industry. (Courtesy Kidd Valley.)

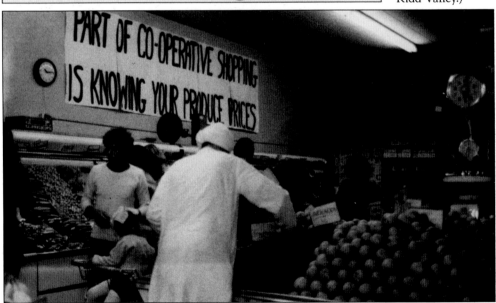

The new site of PCC attracted increased clientele and prompted explosive growth. Membership doubled, sales more than doubled, and staff tripled by 1978. Net earnings in 1974 were $884, by 1977 were $48,219, and by 1978 climbed to $79,190. A survey of PCC customers indicated that consumers were traveling great distances to shop there because the quality and selection of all-natural products were not available elsewhere. (Courtesy PCC.)

Ten

1980 TO PRESENT DAY
VOLCANOES, GRUNGE, AND DAYLIGHTING RAVENNA CREEK

At the start of the 1980s, Seattle's population was 493,846. On the other side of Washington, Mount St. Helens erupted, killing 57 people. Elsewhere in the world, the Iran-Iraq war began. In 1982, Redhook Ale was first sold in Seattle, beginning the microbrew craze, and in 1983, the first Costco discount warehouse opened. In Ravenna, neighbors continued their activism with protests against the spraying of the pesticide carbaryl to combat an infestation of gypsy moths.

By 1990, Seattle's population had grown to 516,259, and the population of Ravenna was 18,747. The median income was $36,680 and median house value $162,353. Fifty-eight percent of the population had completed at least four years of college, and 59 percent owned homes. In 1991, the community blocked a city plan to dig up the park for a new sewer and the park underwent major restoration. Projects included building and maintaining trails as well as "daylighting" portions of the creek (exposing them to daylight), in part to restore native fish runs.

As the decade progressed, Nirvana's *Nevermind* introduced the world to grunge music, and the Boeing 777 took flight. O. J. Simpson was arrested, and Amazon.com sold its first book. Near the end of the year, the United States filed an antitrust suit against Microsoft, and the World Trade Organization meeting deteriorated into rioting with police confrontations, the closing of Seattle's downtown, and imposition of a curfew.

In 2000, Seattle's population was 563,374. The next year, an earthquake measuring 6.8 on the Richter scale shook Puget Sound, causing more than $1 billion in damage, and Boeing moved its corporate headquarters to Chicago. Since 2000, the Ravenna area has seen many changes. Roosevelt High School finished its renovations and reopened to students in the fall of 2006. An award-winning documentary about Roosevelt's girls' basketball team, the *Heart of the Game*, was released. The Ravenna Creek daylighting project was completed. Housing and businesses have grown with new apartment complexes, like Saxe Apartments on the site of Saxe Floral, and many new businesses added to change the face of the University Village. Ravenna residents remain vigilant to any threats to their environment, with the latest concern being the impact of replacement of the Evergreen Point Floating Bridge, which carries State Route 520.

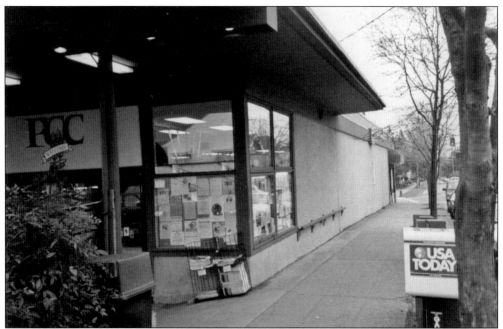

In 1999, Whole Foods Markets opened their first natural-foods supermarket in Seattle in the Roosevelt neighborhood, which borders Ravenna. PCC management was restructured in 2000, the cooperative experienced a net loss of $841,508 after tax credit, and on January 13, 2001, the Ravenna store closed. (Courtesy PCC.)

In the fall of 2002, Third Place Books opened in the old PCC building. An independent bookstore that found success by mixing strengths such as selection and personal customer service with food and entertainment, it was thought particularly well suited to Ravenna, which had a need for a gathering place. The decision to focus on used books was based primarily on size as well as nearby competition. (Courtesy Ann Wendell.)

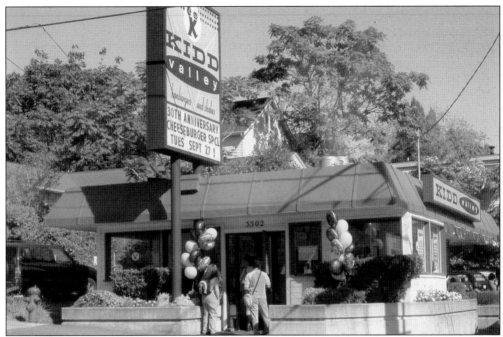

Here Kidd Valley is shown on the day of its 30th anniversary celebration on September 27, 2005. Their fresh, made-to-order burgers and shakes and unique sides, such as fried mushrooms and garlic fries, continue to be a neighborhood draw. The small, enclosed dining area is often crowded with kids after school, working parents picking up dinner, and entire recreational sports teams from the nearby fields. (Courtesy Kidd Valley.)

The present-day interior of the Duchess Tavern is an eclectic mix with a focus on University of Washington sports teams. The present owners, graduates of Roosevelt High School and the University of Washington, have worked hard to create a space where students, sports fans, and neighbors can gather to relax and have fun. (Courtesy Ann Wendell.)

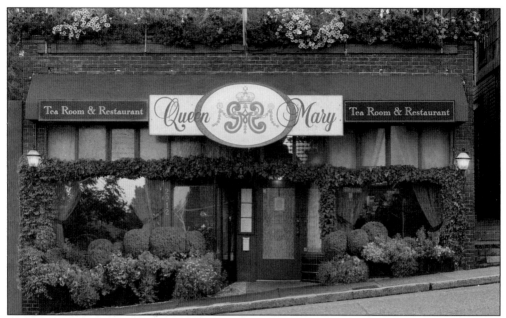

Mary Greengo opened the Queen Mary Tea Room in 1988 to share her passion for tea with the Seattle community. It is popular with both locals and tourists who often return again and again to celebrate special occasions and holidays in the Victorian atmosphere. Named by *Tea and Coffee Trade Journal* as one of the "Great American Tea Rooms," it has become renowned for its afternoon tea, delicious food, desserts, and uniquely decorated cakes. (Courtesy Queen Mary.)

Assumption Catholic Church is located at 6201 Thirty-third Avenue NE. The associated school, Assumption St. Bridget, changed from Assumption School in 1991 and is an elementary school that includes kindergarten through eighth grade. It was founded in 1947 and has been associated with both Dominican Sisters of Tacoma and Benedictine monks. (Courtesy Julie Albright.)

University Unitarian Church was established in 1913 in the University District and moved to the Ravenna neighborhood in 1959. The largest Unitarian Universalist church in the Puget Sound area, it continues to grow and has a current congregation of 700 adult members and a church school of 350 children. (Courtesy Julie Albright.)

Congregation Beth Shalom began almost 40 years ago after Herzl-Ner Tamid Conservative Congregation moved from Seattle to Mercer Island. Over the years, Seattle's Jewish population has grown dramatically, and over 30 percent of the synagogue's members live in Ravenna. Many members of the congregation prefer to live close enough to the synagogue so they can walk there on the Sabbath, an important tradition for many Jews. (Courtesy Julie Albright.)

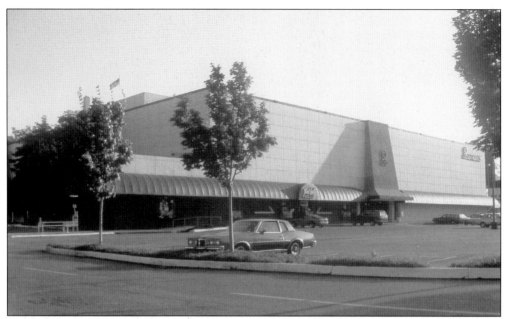

Until the early 1990s, the character of University Village was decidedly different from its current upscale presence. Most of its businesses were small, and the chain stores were all local. One of these was Lamonts, a chain department store founded in Seattle in 1965. The stores were named after Lamont M. Been, the chairman of Pay 'n Save, when that company acquired Rhodes Department Stores in 1965. (Courtesy University Village.)

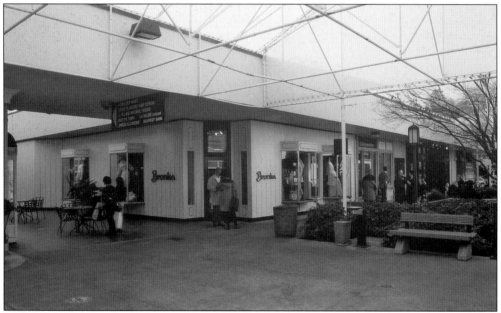

Bronka Serebrin was the longtime owner of Bronka's in the University Village, a unique and elegant women's clothing store. The charming and personable Bronka is often asked to speak on the story of her liberation from Mauthausen concentration camp and her reunion with the American soldier who liberated her. Her story has been told in a PBS documentary, *Reunion*. (Courtesy University Village.)

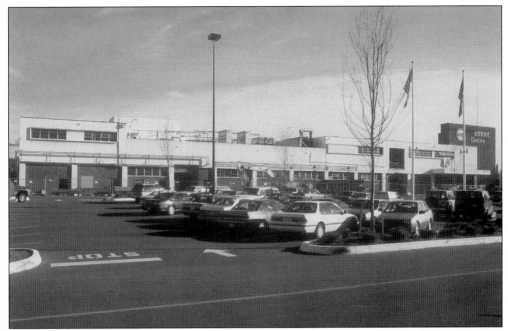

Foremost Dairies, located on the edge of University Village, was founded 51 years ago. It was sold to Quality Food Centers (QFC) early in 1991, and operations at the plant came to a halt in May. Almost all of the 150-plus employees at the Seattle plant were let go. A visit to the dairies was a popular field trip for area youngsters in years past. (Courtesy University Village.)

Before there was Home Depot, Seattle had Ernst Home and Nursery, a defunct home improvement warehouse chain that filed for bankruptcy in the mid-1990s. Founded in Seattle, Washington, in 1893, many of their stores were located in malls, often with a Pay 'n Save, their parent company. The University Village Ernst also included a garden center called Malmo Nursery. (Courtesy University Village.)

Many of the businesses in the University Village began to falter toward the end of the 1980s, and in 1993, the owners of the mall decided to sell to the chairman of QFC and a partner. Some of the improvements included fountains, sculpture, and a play area—all enormously popular with area families with young children that flock to the open, inviting mall. (Courtesy University Village.)

In 2004, the band the Nowhere Men played at the annual Sounds of Summer Concert Series at University Village. The series, which has grown in size and scope over the last decade, takes place over six consecutive Wednesdays in July and August each year. Families and singles come down for free music, "tastes" from the restaurants, and a big Ram beer garden. (Courtesy University Village.)

"U Village," as it is colloquially known, no longer has a hardware store or a nursery but features upscale, national stores such as Restoration Hardware, the Apple Store, Abercrombie and Fitch, Banana Republic, and Tommy Bahamas instead (as well as local specialty stores). Despite this, 61 percent of U Village merchants are still local. (Courtesy University Village.)

Anchor tenants at University Village today include Barnes and Noble, local and family-owned Bartell Drugs, Crate and Barrel, the Gap, and Pottery Barn. Adjacent anchors include QFC's flagship store, Safeway, and Office Depot. In 1991, neighborhood activists initiated a campaign to "daylight" Ravenna Creek through Ravenna Park to Lake Washington, but the segment from the park to the UW was successfully blocked by the University Village owners. (Courtesy University Village.)

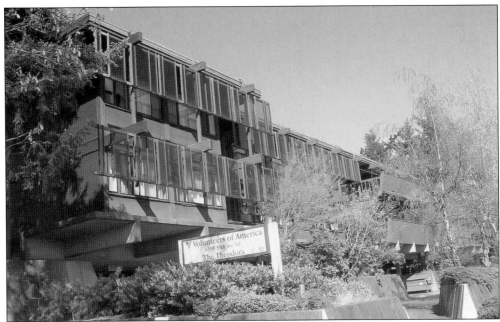

The Theodora continued to provide housing for women and children until 1965. In the mid-1960s, the program focus changed and the Theodora was rebuilt on the same piece of property as a modern Department of Housing and Urban Development (HUD) 130-unit residence for low-income seniors and people with disabilities. Governed by a local board of directors, this corporation still thrives today. (Courtesy the Theodora.)

In 1985, an additional corporation, Volunteers of America Puget Sound, was established with a separate board of directors to govern new social service programs targeted to low-income seniors, children, and families. These programs also included the Senior Companion Program, a summer reading program, and a Seattle neighborhood food bank. The Theodora continues a strong community presence. (Courtesy the Theodora.)

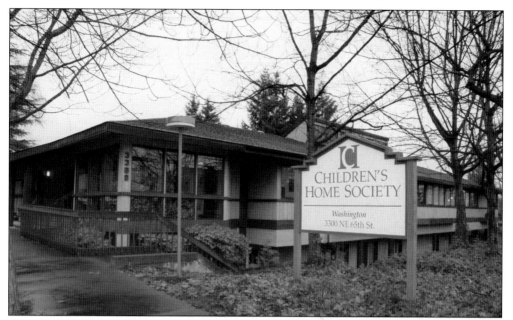

Since 1896, Children's Home Society has continually evolved in response to the changing needs of children and their families. In the last 40 years, it has evolved dramatically from the state's premier adoption agency (1950s and 1960s), to a leading provider of residential and group care for troubled children (1970s and early 1980s), to a nationally recognized, multi-service agency providing a range of family services. (Courtesy CHSW.)

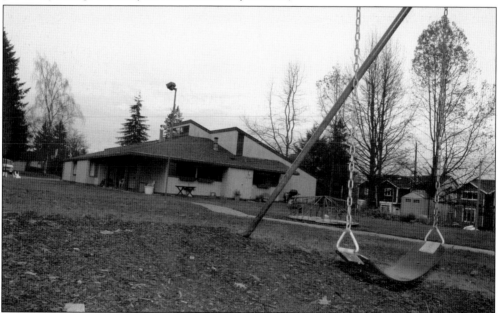

In 1989, CHSW was selected from over 300 applicants for one of the nation's most significant social research projects ever funded. The Families First program is currently demonstrating that families can make the transition from dependency to self-sufficiency when supported by a range of services. CHSW's most recent recognition was selection as a participant in Kellogg's $21.7-million foster-adopt reform initiative called Families for Kids. (Courtesy CHSW.)

The corner of Twenty-fifth Avenue NE and NE Fifty-fifth Street, adjacent to Ravenna Park, has seen many changes over the years, but some things stay the same. Hogan's Corner Laundromat and Dry Cleaners has been in its location and owned by the same family for three generations. The house seen behind it is said to be one of the oldest in Ravenna. (Courtesy Ann Wendell.)

This view down Twenty-fifth Avenue NE south toward the University Village and beyond demonstrates that no neighborhood can stop the signs of progress inherent in the ubiquitous McDonald's. Ravenna's iconoclastic residents are never ones to shirk from their watchful protection of the neighborhood but are tolerant of those who make an effort to fit in and contribute to the community. (Courtesy Ann Wendell.)

In the spring of 2006, the long-awaited daylighting of Ravenna Creek was completed. The project included excavation of 650 feet of new creek channel and enhancement of the existing channel. Other aspects included clearing and grading the site, installing new pathways, stairs, railings, and a pedestrian bridge, installing artwork, restoring the stream corridor, establishing native plants, and seeding. During the public process, King County agreed to allow their funding to pay for relocation of the existing ball field. There was, however, consensus on not locating it on the upper playfield but preserving that as open space. The board of the Ravenna Creek Alliance advocated that the ball field be removed from the park entirely so that the creek could be "the best creek it can be." But given that there appeared to be no alternatives for baseball replacement outside Ravenna Park, it was decided to let it remain. (Courtesy Ann Wendell.)

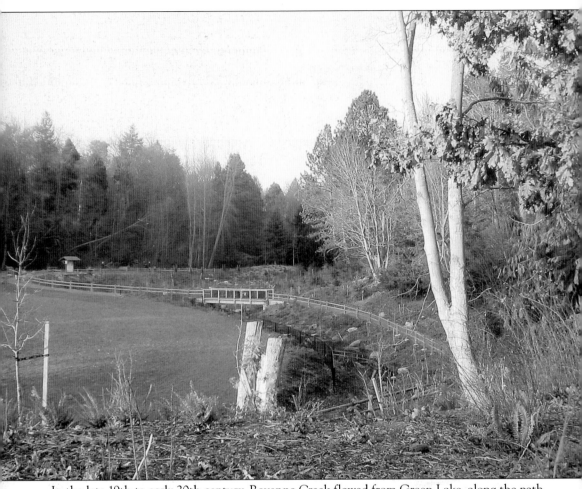

In the late 19th to early 20th century, Ravenna Creek flowed from Green Lake, along the path of Ravenna Boulevard, into Cowen Park. Over time, the creek was reduced, diverted, and filled. In 1911, it was directed into a sewer pipe until 1991, when the Ravenna Creek Alliance took up the mission of daylighting the creek from Ravenna Park to Lake Washington. Today one branch starts out in Cowen Park near the park entrance at NE Sixty-second Street and Brooklyn Avenue NE. A second branch begins near NE Sixty-fifth Street and Twenty-third Avenue NE, and the two branches join in Ravenna Park. Now it's possible to feel the following words written in a 1909 Ravenna Park guide still have resonance:

> In Ravenna Park there is a vastness and wilderness and preciousness not found in such compactness in any other spot. It is an experience to visit it; its tree branches sweeping the stars; its ferns varied and ever green; its moss-clothed canyons; its healing springs of ice-cold waters leave pictures in the memory time can not efface. It takes minutes only to see it, but when seen its memory abides forever.

(Courtesy Ann Wendell.)

Here stands the author in 1965 at age seven. Her stance and the look of determination on her face tell that she will grow up to take her place among the community, joining her fellow residents in ensuring that Ravenna remains the vibrant, feisty neighborhood that it is—full of active social life and abundant natural beauty.

ACROSS AMERICA, PEOPLE ARE DISCOVERING SOMETHING WONDERFUL. *THEIR HERITAGE.*

Arcadia Publishing is the leading local history publisher in the United States. With more than 3,000 titles in print and hundreds of new titles released every year, Arcadia has extensive specialized experience chronicling the history of communities and celebrating America's hidden stories, bringing to life the people, places, and events from the past. To discover the history of other communities across the nation, please visit:

www.arcadiapublishing.com

Customized search tools allow you to find regional history books about the town where you grew up, the cities where your friends and family live, the town where your parents met, or even that retirement spot you've been dreaming about.